Heaven

SONG CERAMICS

and

FROM THE

Earth

ROBERT BARRON

Seen

COLLECTION

Within

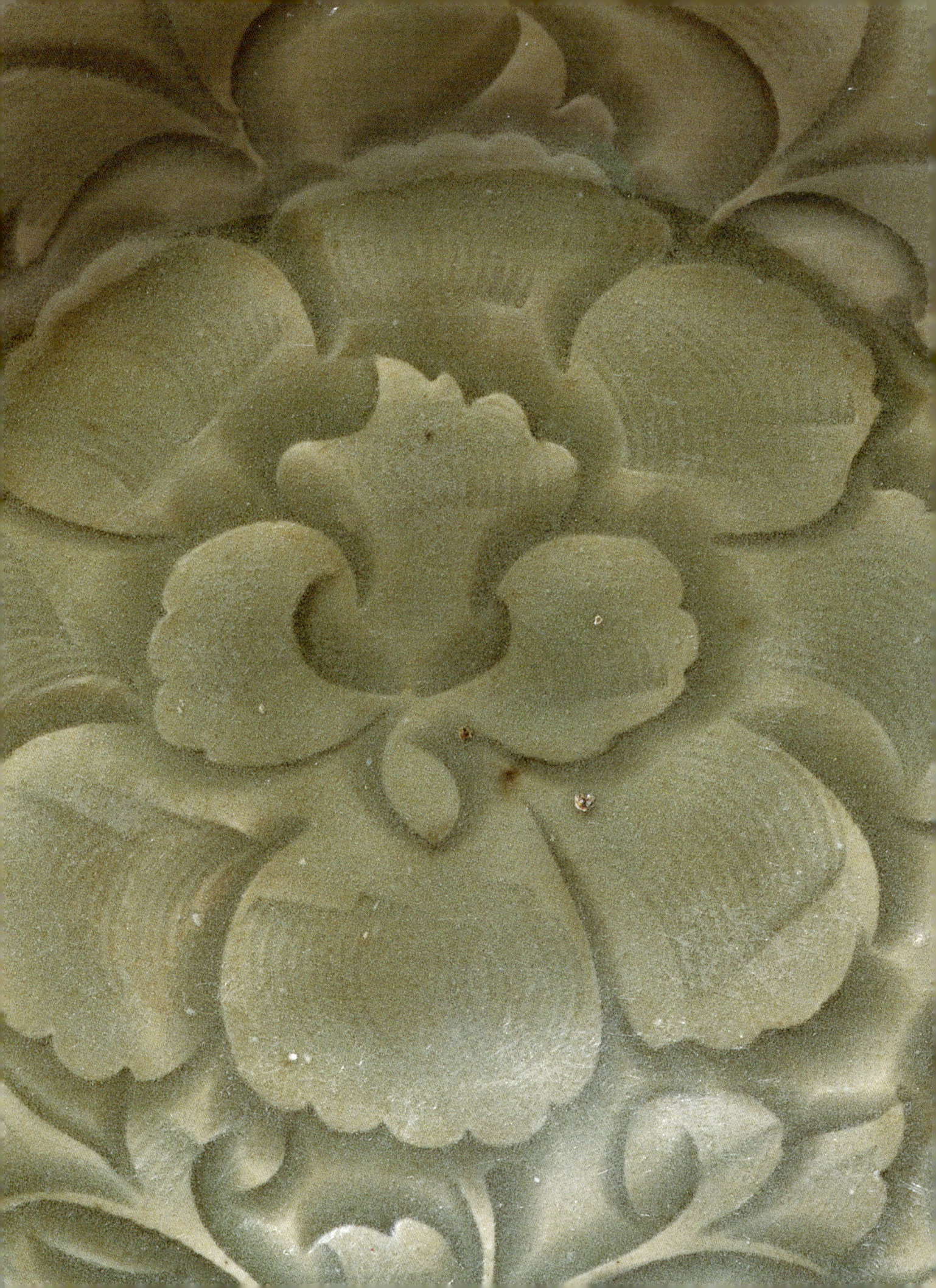

Heaven and Earth Seen Within

SONG CERAMICS FROM THE ROBERT BARRON COLLECTION

Lisa Rotondo-McCord

Introduction by Robert D. Mowry

New Orleans Museum of Art
2000

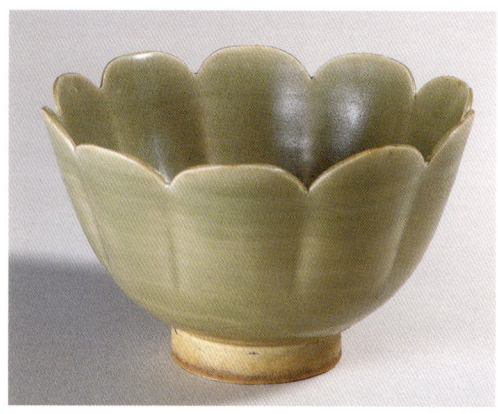

2,000 copies of this book were published in conjunction with the exhibition *Heaven and Earth Seen Within: Song Ceramics from the Robert Barron Collection*, organized by the New Orleans Museum of Art, presented March 4 through May 18, 2000.

Headley-Whitney Museum, Lexington, Kentucky
June 29 – August 24, 2000

The Taft Museum, Cincinnati, Ohio
December 8, 2000 – February 19, 2001

Elvehjem Museum, University of Wisconsin, Madison
March 9 – May 13, 2001

©2000 New Orleans Museum of Art. All rights reserved. No part of this publication may be reproduced in any manner whatsoever without the written permission from the publisher.

Library of Congress Catalogue Card Number: 99-75231
ISBN 0-89494-077-5

Heaven and Earth Seen Within: Song Ceramics from the Robert Barron Collection was produced by the Publications Office of the
New Orleans Museum of Art, Wanda O'Shello, Coordinator
Designed by Bridget McDowell and Aisha Champagne,
New Orleans Museum of Art
Photography by Maggie Nimkin
Printed and bound by C & C Offset Ltd., Hong Kong

Cover: *Large Yueyao Box* (detail), cat. 3
Frontispiece: *Carved Yaozhou Bowl with Peony Design* (detail), cat. 11
Above: *Yaozhou Lobed Bowl*, cat. 8
Page 8: *Black-Glazed Ribbed Zhadou with Foliate Rim*, cat. 25
Page 31: *Small Black-Glazed Conical Bowl Dappled in Russet* (detail), cat. 35
Back Cover: *Small Black-Glazed Conical Bowl with Russet Mottles* (detail), cat. 34

Page vi, Poem from a translation by Edward H. Schafer, *Mirages on the Sea of Time: The Taoist Poetry of Ts'ao Tang* (Berkeley, 1985), pp. 62-63.

Contents

Foreword E. John Bullard	6
Acknowledgements Robert E. Barron, III	7
Chronology	8
Map	9
Song Ceramics: An Overview Robert D. Mowry	10
Catalogue Lisa Rotondo-McCord	31
Selected Bibliography	158

Director's Foreword

E. John Bullard
The Montine McDaniel Freeman Director

...But I realize now that a Heaven and an Earth can be seen within a pot:
Heaven and Earth within a pot—but not once an autumn!
 Cao Tang (fl. 847-73)

Refined in form and glazed in predominantly monochrome colors in shades derived from nature, Song ceramics were created not only as utilitarian objects—tea bowls, cosmetic boxes, and storage jars—but also as objects for contemplation. Made from the clay of the earth, these vessels are transformed by their glazes and decoration into objects which recall the unending cycles of nature and the vastness of the universe.

Connoisseurs and collectors have long considered Song-dynasty ceramics to be the sublime expression of the Chinese potter's art. New Orleans is fortunate to have in its community Dr. Robert Barron, who has created a superb collection of Song ceramics. Long a friend of the Museum, Bob's enthusiasm for these wares is contagious and he has generously shared his expertise through the years.

The Barron Collection includes select examples of both court-taste and popular wares, created at some of the most important Song and Jin kilns. The survey of Song ceramics presented by the collection illuminates the unique characteristics of each period and type of ware, and demonstrates the interrelationship of style, form and decoration among disparate kiln sites. The nature of these connections has been explored, both in the catalogue essay and individual entries, drawing upon recent archaeological evidence from tomb and kiln excavations.

This exhibition and catalogue would not have been possible without the expertise and assistance of many people. I would especially like to thank Dr. Robert Mowry, Curator of Chinese Art at the Harvard University Art Museums, who served as guest curator of the exhibition, for crafting the finely wrought introductory essay. Lisa Rotondo-McCord, NOMA's Curator of Asian Art, supervised the exhibition, researched, and wrote the catalogue entries. We are delighted to share this exhibition with the Headley-Whitney Museum in Lexington, Kentucky, the Taft Museum in Cincinnati, Ohio, and the Elvehjem Museum at the University of Wisconsin. We thank Diane C. Wachs, Director, and Lisa Blackadar, Curator, of the Headley-Whitney, Phillip C. Long, Director, and David Johnson, Assistant Director/Chief Curator, at the Taft, and Russell Panczenko, Director, and Maria Sassiotti Dale, Curator, at the Elvehjem, for their enthusiastic support.

The beautiful photography for the catalogue is the work of Maggie Nimkin, whose love of Song ceramics is evident in each and every image. At the Museum, special thanks are due to our Publications Coordinator, Wanda O'Shello, for her expert editing and management of the catalogue production process. Designed initially by Bridget McDowell, the catalogue was brought to fruition by Aisha Champagne, our new Graphics Coordinator. The assistance of Paul Tarver, Michael Guidry and Jennifer Ickes of the Registrar's Department is also much appreciated. Likewise, Patricia Pecoraro, Curator of Exhibitions, and her staff have done an outstanding job in installing the exhibition.

Our final and greatest thanks, of course, go to the collector, Bob Barron. For over forty years he has collected with a connoisseur's eye and a scholar's mind. Meticulous in his research and unerring in his judgement, we thank him for this opportunity to see, as did the ninth-century Chinese poet, "heaven and earth" within a pot.

Acknowledgements

Robert E. Barron, III, M.D.

The formation of this collection has been my passion for much of my adult life. I am grateful for the encouragement and assistance of a great many people: scholars, fellow collectors, dealers, and experts at the auction houses. In my early years of collecting, dealers such as Warren Cox, Mathias Komer, J.T. Tai and Frank Caro graciously shared their knowledge and expertise; many fruitful hours were spent in their presence.

I would especially like to thank fellow collectors Mr. and Mrs. Myron Falk, Jr., for their encouragement and kindness over the years. Likewise, dealers and experts have provided invaluable assistance. Special thanks to: Roger Bluett, Brian Morgan and Dominic P. Jellinek of Bluett and Sons, Ltd., London; Jim Lally, while at Sotheby's and later at J.J. Lally and Co., Oriental Art; Guiseppe Eskenazi of Eskenazi Ltd.; Carol Conover, while at Sotheby's and presently at Kaikodo; and Patricia Curtain and Theow-Huang Tow of Christie's.

I am truly grateful to those who have brought this catalogue and exhibition to life. Special thanks are due to Bob Mowry, for his great expertise and masterful introductory essay. Bob's long-standing interest in the collection has resulted in many hours of thought-provoking discussion. Maggie Nimkin created the extraordinary photographs for the catalogue; they are a pleasure to behold. I would also like to express my gratitude to Lisa Rotondo-McCord for her tremendous work on the catalogue.

Chronology of Dynastic China

Shang	circa 17th century B.C. – 1028 B.C.
Zhou	1027 – 221 B.C.
Western Zhou	1027 – 771 B.C.
Eastern Zhou	771 – 221 B.C.
Spring and Autumn Period	722 – 481 B.C
Warring States Period	481 – 221 B.C.
Qin	221 – 206 B.C.
Han	206 B.C. – A.D. 220
Western Han	206 B.C. – A.D. 9
Xin	9 – 25
Eastern Han	25 – 220
Six Dynasties Period	220 – 589
Sui	581 – 618
Tang	618 – 907
Five Dynasties Period	907 – 960
Liao	907 – 1125
Song	960 – 1279
Northern Song	960 – 1127
Southern Song	1127 – 1279
Jin	1115 – 1234
Yuan	1279 – 1368
Ming	1368 – 1644
Qing	1644 – 1911

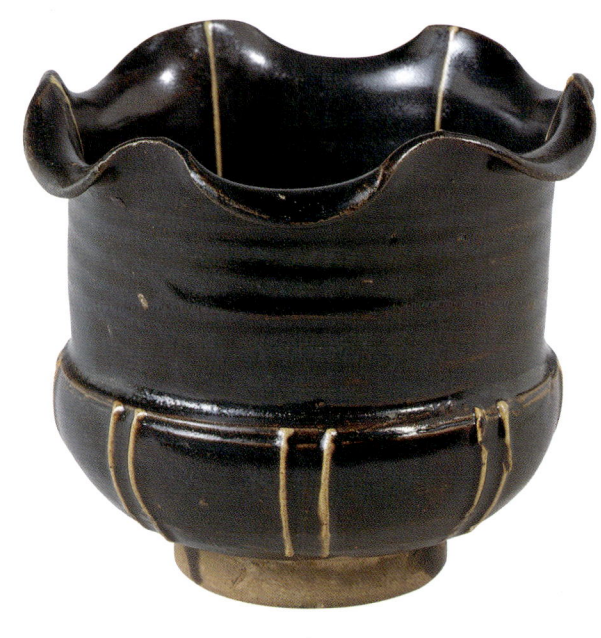

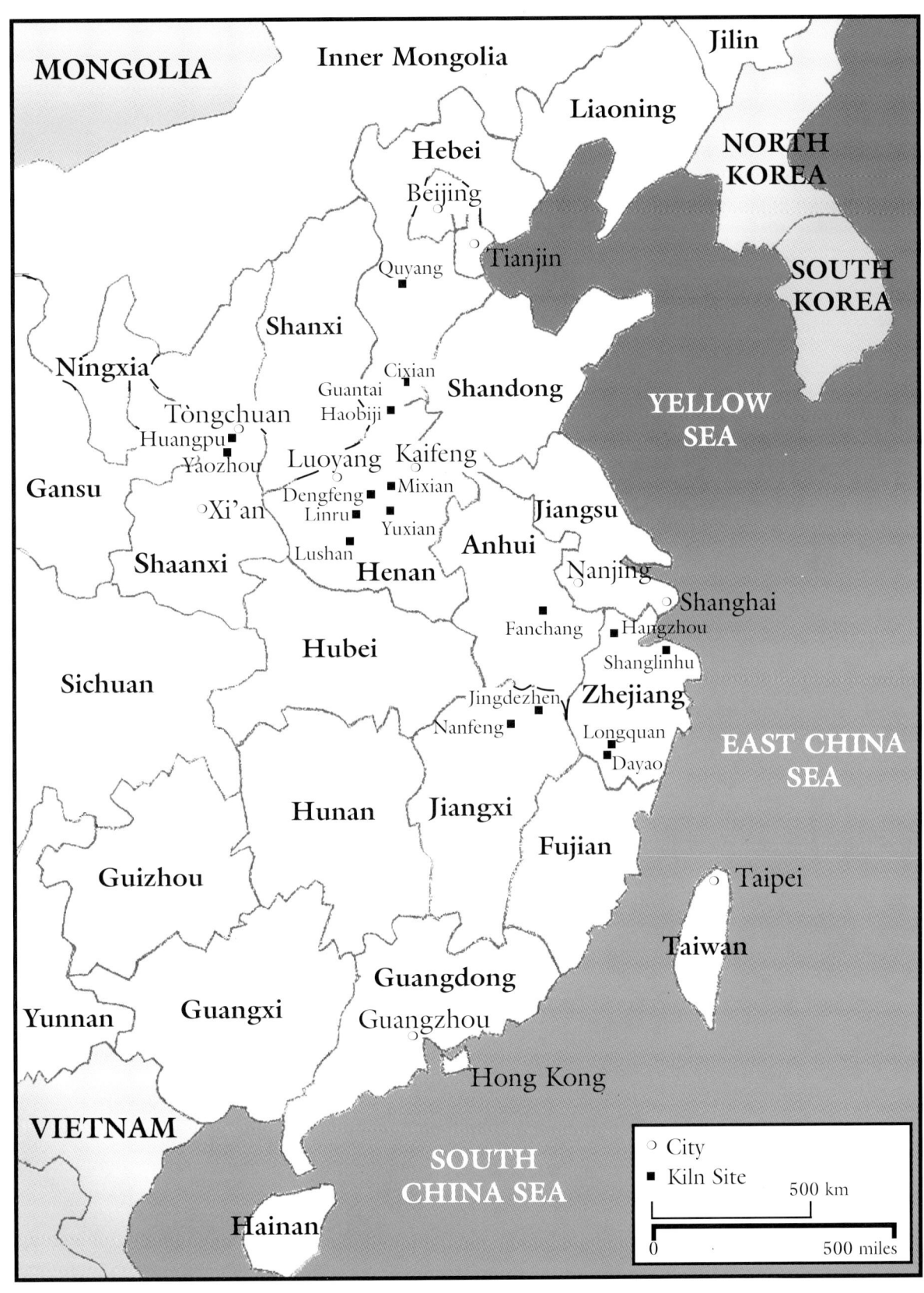

Selected Song-Period Kiln Sites

Song Ceramics: An Overview

Robert D. Mowry

If the Tang Dynasty (618-907) was an age of military splendor, the Song was one of scholarly refinement. The powers of the military had been curbed, so that the imperial court and the bureaucracy were dominated by civil officials who had gained entry into government ranks through the civil service examinations, preparation for which required years of patient, assiduous study in the Confucian classics—history, literature, philosophy; those who passed them naturally constituted the nation's cultured élite.

Song history divides itself neatly into three distinct periods: the Northern Song (960-1127), the Southern Song (1127-1279), and the Jin (1115-1234). During the Northern Song period, the emperors ruled the whole of China from Bianjing (modern Kaifeng), then the capital. In 1127, Jin Tatars overran Bianjing, toppling the government and causing the legitimate Chinese rulers to take refuge in the south, where they established a new capital at Hangzhou, then called Linan. From 1127 onward, China was partitioned into two states: the north, under the rule of the Jin Tatars, and the south, under the Song emperors. Invading Mongols overthrew the Jin in 1234, taking control of north China, and in 1279, they deposed the Song emperor, uniting China under foreign rule—the Yuan, or Mongol, Dynasty (1279-1368). Although the ceramics of these periods are closely related, distinct styles are associated with each.

In general, patrons of the Song kilns preferred monochrome glazed stonewares to the often rather brightly colored wares that had appealed to their forebears in the Tang. The more aristocratic of the Song wares—the expensive ones favored by the

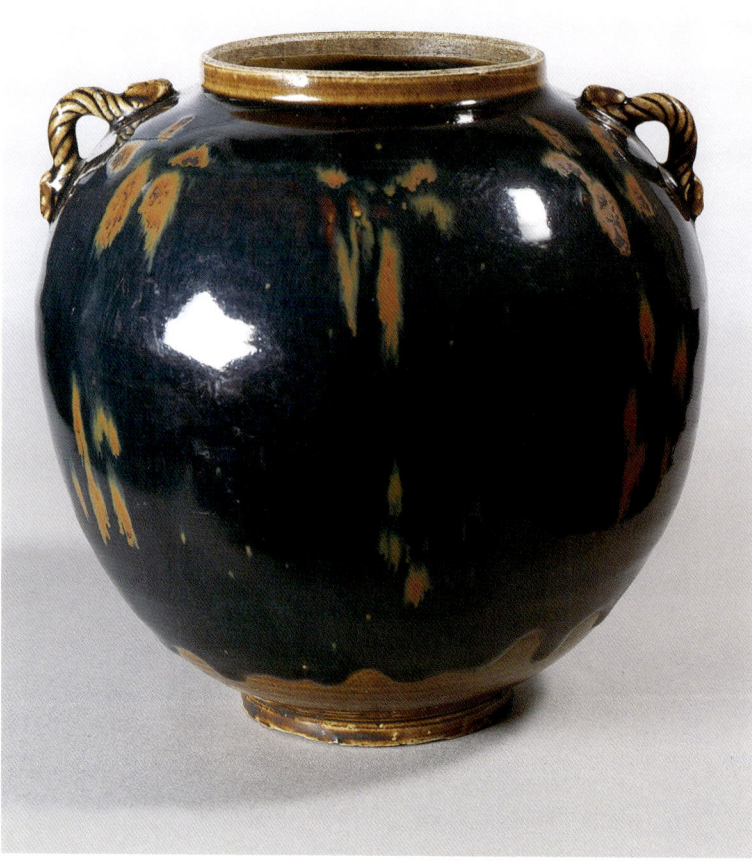

CAT. 31
LARGE BLACK-GLAZED GLOBULAR JAR WITH RUSSET DECORATION AND ROPE-TWIST HANDLES

10

imperial court and upper classes—exhibit elegant shapes and subtly colored glazes that range from ivory and pale bluish-green to robin's-egg blue. They may have delicately incised floral decoration or they may rely solely upon purity of line and beauty of glaze for their aesthetic appeal. The more humble wares—those used by people of lesser means—typically exhibit exuberant designs and boldly conceived decoration, often in black or brown.

Featuring sixty-five exquisite pieces that Dr. Robert E. Barron, III collected over several decades, this exhibition provides a superb introduction to Chinese ceramics of the Song Dynasty (960-1279). White porcelains, bluish-green celadons, and dark-glazed wares are all represented in abundance, permitting an in-depth exploration of every important Song ceramic tradition.

Prior to the fourteenth century, the glaze colors for high-fired ceramics were limited to colors derived from iron compounds. Lacking specific symbolism, brown and black glazes evolved as potters attempted to expand the range of glaze colors beyond the well-known celadon, or sea-green, which was the earliest high-fired glaze to develop. Different as they might seem, the celadon and dark glazes are closely akin, both relying on iron oxide as their principal coloring agent. In the proper kiln atmosphere, a pale, bluish-green color—like that of window glass—appears when concentrations of iron oxide reach 0.8 percent. As the amount of iron oxide increases, the color deepens, with concentrations of one to three percent yielding celadon glazes. Additional iron oxide results in brown glazes; those with concentrations of five percent or more turn dark brown, appearing black to the naked eye when sufficiently thick.

Because iron is present in prodigious quantities in the earth's crust, and thus in the clays used to make ceramics, Chinese potters no doubt discovered the secrets of celadon manufacture with relative ease, once they began to experiment with intentionally applied, high-fired glazes in the Warring States and Han periods. If that discovery came relatively quickly, their search for agents with which to expand the range of glaze colors proceeded slowly because few natural glaze colorants can withstand the temperatures in excess of 1,150 degrees centigrade that are necessary to create high-fired stonewares. In fact, the use of copper and cobalt—the other two elements used as coloring agents for high-fired glazes in traditional times—would not be mastered until the fourteenth century. All high-fired, colored glazes on wares made before the fourteenth century thus necessarily rely on compounds of iron for their color and are closely related.

The colors of high-fired ceramics made from the Han through the Song Dynasties are quiet and reserved, akin in spirit to the monumental landscape scrolls painted by Fan Kuan (late tenth-early eleventh century) and Guo Xi (ca. 1020-1090). Whether or not people of the Song Dynasty might have appreciated brightly colored, monochrome-glazed ceramics can be no more than an academic question; because technical limitations prevented the production of brilliantly hued glazes—strawberry reds, cobalt blues, emerald greens, chrysanthemum yellows—until post-Song times, there simply is no way to know whether Song patrons might have enjoyed them alongside, or even preferred them to, their white-, celadon-, and dark-glazed ceramics. Within those limitations, potters of the pre-modern era exploited the possibilities of iron to create a varied, if subtle, palette that culminates in the wares of the Song and Jin periods, their "Golden Age."

The following sections introduce the various categories of Song and related ceramics represented in the Barron Collection. Arranged by type of ware, the discussions describe the basic characteristics of each ware, provide background information on the kilns in which the ceramics were fired, and note the salient stylistic features that permit individual pieces to be identified and dated.

Yue Ware

Remains of the Yue kilns, which number in the hundreds, encircle Shanglinhu, or Lake Shanglin, which is near Cixi, in northeastern Zhejiang Province.[1] The term "Yue," used in modern art-historical parlance for both the kilns and the ceramics they produced, is the literary, or classical, name for Zhejiang Province; it derives from the name of the ancient Yue state, which ruled that area during the Eastern Zhou period (771-221 B.C.). Kilns were active at Shanglinhu from the Warring States period (481-221 B.C.) through the Northern Song period; overshadowed by their competitors, the Yue kilns fell into decline during the Northern Song and ceased production in the Southern Song.

The Yue kilns precipitous decline in the Northern Song was surprising because during the preceding Tang and Five Dynasties (907-960) periods, these kilns were the most sophisticated in China—indeed, in all the world. They not only produced prodigious quantities of ceramics, as attested by the great number of kiln remains,[2] but supplied exquisitely refined celadon wares to the palace. During the thousand years from the Han (206 B.C.-A.D. 220) through the Five Dynasties period, the Yue kilns pioneered and then perfected celadon glazes,[3] laying the technical and aesthetic foundations for the glorious wares that typify the Song Dynasty. Already in the Han Dynasty, potters in the region had begun to experiment with intentionally applied celadon glazes; during the succeeding centuries, they overcame the major challenges of glaze fit, glaze color, and high-temperature firing.

By the Han Dynasty, if not earlier, Yue potters had invented the "dragon kiln" (*longyao*), an arched, tunnel-shaped oven built on the side of a hill; constructed of bricks, such dragon kilns typically stretched forty to fifty feet in length, the longest measuring more than three hundred feet. The long inclined firing chamber, in which the ceramics were placed, linked the fire box at the bottom to the chimney at the top; as such, the firing chamber not only served as a conduit for fire's heat and smoke but aided in the creation of a strong draft, thereby elevating the kiln temperature. Fueled with wood from the area's abundant forests, such kilns, which easily could sustain temperatures in excess of 1100 degrees centigrade, permitted the production of high-fired stoneware, the fabric the potters relied upon to showcase their exquisite celadon glazes. By channeling the smoke, with its carbon monoxide and other combustion products, through the firing chamber, dragon kilns also facilitated reduction firing, a requisite for achieving bluish-green-hued celadon wares. Should fresh air, with its free oxygen, enter into the chamber during firing, the glazes would mature olive-green instead of the desired bluish-green. Still, perfection of reduction firing required centuries of trial-and-error experimentation. In fact, only late in the Tang period did the kilns begin to produce perfectly hued celadons with any regularity—the so-called *mise*, or "secret color," wares celebrated in literature of the Tang and Five Dynasties period.[4] During those centuries, the potters also solved the problem of glaze fit by devising glaze mixtures whose compositions were compatible with the ceramic bodies they covered; that is, not only did the glazes bond to the underlying stoneware bodies but because bodies and glazes shared similar coefficients of expansion and contraction, the glazes did not crack, craze, or flake during or following firing.

Celadon glazes and dove-gray stoneware bodies have typified Yue wares since earliest times; that technical excellence was matched on the aesthetic side by inventive forms and exquisite decoration. The Barron Collection includes four examples of Yue ware, all from the tenth century, when the wares attained maturity.

On first inspection, the spherical box (cat. 1) resembles a plump fruit, though the "pleats" around its cover probably represent overlapping petals, making an open but

inverted blossom the more likely model. With its full, rounded form and naturalistically decorated cover, this box represents a transition between the Tang style, which emphasizes taut, geometric forms, and the Song style, which favors fruit and floral forms.[5] Supposedly invented by lacquer artists, the cup stand was often fashioned in silver during the Tang dynasty and then imitated in ceramic ware during the Five Dynasties and Song periods.[6] Basically an elaborate saucer, the cup stand proved the perfect complement for a small cup of hot tea or warmed wine. Cup stands made at the Yue kilns typically feature a flat-rimmed saucer set upon a tall circular foot; from the center of the saucer rises the distinctive, mound-shaped stand that receives the tea or wine cup (cat. 2). By contrast, cup stands made at kilns in the north tend to have a hollow, cup-shaped receptacle that rises from a saucer with gently rounded sides. In addition, although cup stands made at northern kilns tend to be unembellished, those from the Yue kilns often sport incised and carved decoration—rolling waves wash the flat rim of this cup stand, for example, while an incised blossom embellishes the top of its central stand and carved lotus petals encircle its sides; not to be outdone, the slightly conical base, which is itself notched and scored to simulate an inverted blossom, boasts reticulated trefoil designs.

Probably for cosmetics, the large, circular covered box (cat. 3) features a design of two Mandarin ducks with intertwined necks, the scene framed by a lotus scroll with an open blossom at the top, a seed pod at either side, and a broad leaf with undulating edges at the bottom. Mandarin ducks symbolized marital fidelity in traditional China; the inclusion of seed pods, rather than buds, in the bordering lotus scroll may amplify that symbolism. The cover's circular form suggests a pond, just as surely as the delicately incised lines around its shoulder suggest the water in which the ducks swim. Small, circular, covered boxes appear among the repertoire of Han-dynasty silver and may have served as the model for the symmetrical gold and silver boxes of the Tang dynasty, the ancestor of this exquisite box.[7] The two halves of such Tang metal boxes usually mirror each other in shape, often having vertical walls, rounded corners, and flat or lightly domed covers; both halves characteristically are decorated, typically with a floral arabesque—sometimes inhabited by a variety of animals and birds—set against a ring-punched ground. Potters at the Yue kilns began to make covered boxes in the ninth or tenth century; their boxes imitate the form and even the decoration of examples in precious metals, though their decoration usually is limited to the cover. Like the Barron Collection spherical box (cat. 1), this circular box might be termed a transitional piece; its flattened form and slightly concave base perpetuate the late Tang style, yet its naturalistically rendered, pictorial decoration, which rises in subtle

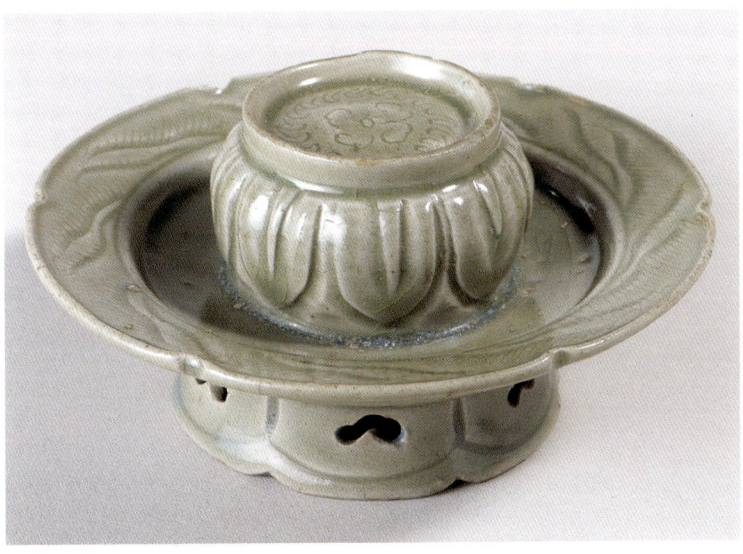

CAT. 2
YUEYAO CUP STAND

13

relief, anticipates the Northern Song. Covered boxes in the fully developed tenth-century style often have a flat base and a lightly splayed foot ring on the container's underside. Apart from its satisfying form and pleasing decoration, this box's most remarkable feature is its glaze, which is not only clear and transparent but perfectly hued.

The fourth Yue piece in the Barron Collection, a small globular jar with two tiers of lotus petals bordered at the bottom by a ring of sepals (cat. 4), also derives its shape from a Tang silver vessel. Its interpretation as an opening lotus bud distinguishes this Five Dynasties jar from its Tang prototype, which would have emphasized geometry of form over naturalistic depiction. A small cover—perhaps with rounded sides and slightly domed top, possibly with inclined sides and subtly pointed top—originally crowned this jar, protecting the vessel's contents and completing its form by resolving its uncompleted curves. Such rounded jars were popular in a variety of ceramic wares made in the tenth, eleventh, and twelfth centuries.

Ding Ware

Collectors of the Ming (1368-1644) and Qing (1644-1911) dynasties ranked Ding ware among the "five great wares of the Song," along with Jun, Ru, Guan, and Ge wares. Celebrated for their porcelaneous white wares, the Ding kilns also produced pieces with russet, dark brown, and black glazes; they even made rare examples with low-fired, lead-fluxed, emerald-green glazes. Although they were not imperial kilns per se—that is, they were not operated by the government and did not produce ceramics exclusively for the imperial household—the Ding kilns nevertheless supplied substantial quantities of ceramic ware to the palace in the late tenth, eleventh, and early twelfth centuries.

Produced at a number of kilns in Quyang County, in western central Hebei province from the eighth through the thirteenth or fourteenth century, Ding ware is so named because Quyang County fell within the Dingzhou administrative district during the Song.[8] The Ding potters relied upon small, circular, domed kilns for firing their ceramics. Kilns of such shape, which had been popular throughout north China since antiquity, today are termed *mantou*, or "bun-form," kilns, after the steamed bread rolls of the same name and form. The Ding kilns were quite small, often measuring no more than six to ten feet in diameter; in the early phase of production they were fueled with wood, but from the tenth century onward they relied upon coal.

Chinese potters began to experiment with high-fired white ceramics—usually opaque white stonewares—in the Sui dynasty (581-618); by the eighth century, they had invented porcelain, which is both white and translucent. During the Tang dynasty, the finest porcelains, many of which were supplied to the imperial palace, were made at the Xing kilns, near Neiqiu, which is in southern Hebei province, about ninety miles south of Quyang.[9] The earliest Ding potters doubtless imitated Xing ware, as early Ding examples retrieved from the kiln site closely resemble Xing wares. In his *Chajing* (Classic of Tea) of 760, the Tang author Lu Yu compared snow-white porcelain to silver; in fact, the earliest Chinese taste for porcelain coincides with a surge in popularity for vessels of gold and silver, reflecting the relationship between the ceramic and precious-metal traditions. Even if vessels of Xing porcelain were used in Tang palaces, Lu Yu remarked that celadon-glazed vessels—that is, vessels of Yue ware—which he compared to jade, were still the most preferred, at least for serving tea.

Though not a palace ware during the Tang, Ding ware gained imperial favor in the tenth or eleventh century, by which time the Xing kilns had ceased production. Elegant

forms derived from contemporaneous silver and lacquer typify Ding wares of the Northern Song (cat. 5-7), as do thin walls that result in pieces of unusually light weight. The smooth, fine-grained, white bodies of Ding ceramics are only slightly translucent, transmitting a warm orange light when they transmit light at all. Thin and pale, their slightly olive glazes impart an ivory hue to the finished pieces; that warm tonality resulted from the burning of coal to heat the kilns, a fuel that promotes oxidation firing, in which air with abundant free oxygen is heated and channeled into the firing chamber. (Oxidation firing can be considered the opposite of reduction firing, mentioned above.) Connoisseurs early on recognized that runs of glaze, which they termed "tear drops," characteristically appear on the exteriors of Ding vessels.

Ding vessels from the tenth and early eleventh century are usually undecorated, though they often suggest natural forms. With the notches about its rim and the scored vertical lines below, the Barron Collection small Ding bowl (cat. 5) imitates an open blossom, for example. The larger bowl (cat. 7), which was created a few decades later, sports low-relief ribs that radiate from its floor to meet the notches in its rim, thereby separating one petal from the next. In this case, after it had been turned on the potter's wheel, the bowl was placed over a fired but unembellished stoneware mold, which defined its circular floor and imparted the exact curvature to its profile. Once the clay had dried, the ribs were trailed onto the interior walls by extruding white slip—clay ground to a fine powder and mixed with water—from a pliable bag with a nozzle (doubtless something akin to a modern pastry bag or cake decorator). Unrepresented in the Barron Collection, Ding vessels from the late eleventh and early twelfth century typically sport incised and carved decoration, while those from the mid-twelfth through the thirteenth century characteristically boast mold-impressed decoration.

Like high-quality ceramics made at other kilns during the Song Dynasty, those made at the Ding kilns were fired in thick-walled saggars, or ceramic firing containers, to insulate them from minor fluctuations in firing temperature and to protect their glazes from soot and other combustion products in the smoky atmosphere of the kiln. From the late tenth or early eleventh century onward, white Ding vessels of open shape—dishes, basins, bowls, etc.—were stacked upside down in their saggars to increase kiln efficiency; because their mouth rims were wiped free of glaze to prevent them from fusing to the saggar, such pieces were banded with metal after firing to conceal the unglazed rim. Wide metal bands originally concealed the unglazed rims of the two Ding bowls in the Barron Collection. However, another reason explains the unglazed lip of the Collection's undecorated Ding ware jar (cat. 6). That is, before the tenth century, covers were typically fired separately from the vessels they were intended to cap. Although it allows the vessel's lip to be fully glazed, this firing method necessitates that the mouth of a jar, for example, be slightly larger than its associated cover in order to ensure that, despite kiln shrinkage, the cover will fit after firing; the result is that covers of pre-Song vessels seldom fit snugly. From the tenth century onward, standard practice demanded that covers be fired in place in order to achieve a perfect fit; the "price" was that the top and interior of the vessel's lip and the underside of the cover's lip, not to mention its downward-projecting flange, had to be left unglazed so that the melting glaze would not fuse cover and vessel together in the heat of the kiln. Thus, an unglazed lip on a jar of Song or post-Song date generally indicates not only that the jar was intended to be covered but that a cover was fired in place. Only rarely do jar-and-cover sets survive. To appreciate a jar lacking its cover, such as the fine Ding example in the Barron Collection, one must envision the vessel crowned by a domed cover with a horizontal lip; the dome would echo and complement the jar's strong curves, thus completing the ensemble.

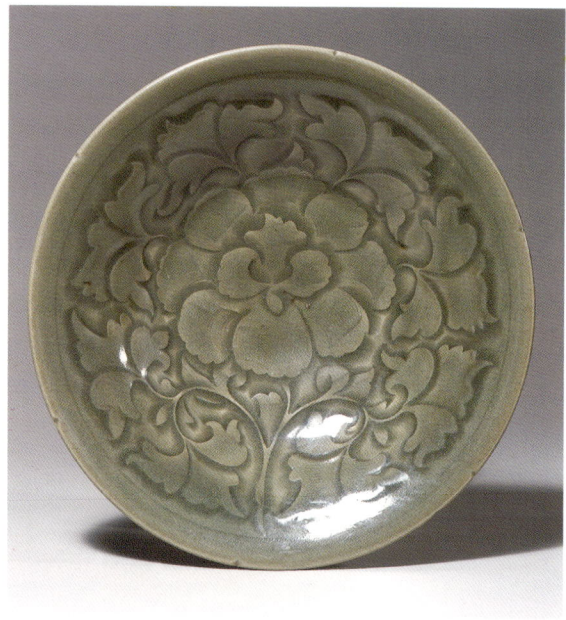

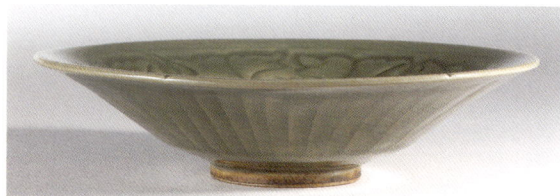

CAT. 11
CARVED YAOZHOU BOWL WITH PEONY DESIGN

Yaozhou Ware

The Barron Collection includes eight examples of celadon-glazed Yaozhou ware, which was made at a large complex of kilns outside modern Tongchuan, which is in central Shaanxi Province, about sixty miles north of Xi'an, the provincial capital. The term "Yaozhou"—the name used during the Song Dynasty for the administrative district in which the kiln complex is located[10]—today designates the ceramics made in those kilns; the name used for those ceramics during the Song Dynasty remains unknown.

The Yaozhou kilns trace their origins to the Huangpu kilns, which in Tang times were celebrated for their prodigious output of black- and tea dust-glazed ceramics and for their experiments with white- and celadon-glazed wares.[11] By the Northern Song, the Huangpu kilns had perfected a variety of celadon ware with carved floral decoration under a thick but transparent, lustrous glaze. The ware appealed to the aristocratic taste of the day and was apparently supplied to the palace as tribute in the late eleventh and early twelfth century; like the Ding kilns, however, the Yaozhou kilns were never classed as imperial kilns. Even after celadon wares became their mainstay, the Yaozhou kilns continued the production of both white and dark wares throughout the Northern Song and Jin periods. In fact, recent excavations have revealed that the Yaozhou kilns produced russet-glazed stonewares in abundance, second in quantity only to celadons; black-glazed wares trailed russet wares in quantity, as white wares trailed black wares.

Huangpu and Yaozhou wares were fired in a variant of the northern *mantou* kiln. Often measuring twenty feet in length, the Yaozhou kilns were much larger than the *mantou*-type kilns used to fire Ding ware; in plan, they were not circular, like the Ding kilns, but square (with rounded corners) or even horseshoe-shaped. A fire wall just inside the firing chamber directed the heated air and smoke upward to the domed ceiling, which, in turn, radiated them downward through the chamber. The smoke and other combustion products could exit only after diffusing through the chamber, as the chimney flues were set at floor level, opposite the fire box and intervening fire wall. This ingenious arrangement of fire wall, domed ceiling, and chimney flues facilitated even heat distribution through the firing chamber; in addition, by preventing the immediate escape of heat (together with the smoke and other combustion products) through a chimney flue at the center of the domed ceiling—an arrangement characteristic of many *mantou*-type kilns—this combination enabled the Yaozhou kilns to attain very high temperatures.[12] In Tang times, the Yaozhou

potters burned wood to heat their kilns; by the Song, they had switched to coal, a fuel that typically produces an oxidizing atmosphere. (Even today, coal is a staple product of the Tongchuan area.) As expected, Yaozhou potters placed their ceramics in saggars for firing. Following convention, except at the Ding kilns, they stacked their pieces right side up in the saggars; thus the finished pieces have glazed mouth rims but foot rings with unglazed bottoms.

The earliest Yaozhou potters looked to Yue ware (compare cats. 1-4) as the model for their celadons, taking technical and aesthetic inspiration from that very sophisticated and rightly celebrated tradition. Like the Yue potters, they made thin-walled vessels of pale gray stoneware, which they covered with rich, transparent glazes. Most Yaozhou celadon glazes exhibit an olive hue, though rare examples occasionally appear bluish-green. Exposed body glaze, visible on the bottoms of foot rings, for example, characteristically assumes a buff skin in firing.

Celadon vessels made at the Yaozhou kilns during the tenth century and the first part of the eleventh often eschew surface ornamentation in favor of naturalistic shapes. Thus the cusped rim and scored walls impart the form of an open blossom—perhaps a lotus—to the eleventh-century lobed bowl (cat. 8); in like manner, the small jar resembles a ripe melon, thanks to its segmented walls (cat. 9).

During the eleventh century the Yaozhou kilns came into their own, the potters fully self confident, their exquisite ceramics widely renowned. As their fame spread and their market expanded, the kilns began to produce wares of great diversity and sophistication; the potters created many new and highly innovative shapes, such as the small, *zhadou*-form jar with foliated rim (cat. 10), and they embellished their wares with vibrant floral patterns (cats. 11-15).

The ornamented Ding wares of the eleventh and early twelfth century characteristically feature subtle floral decoration; their delicately carved designs echo the restrained elegance of the ivory-white porcelain. In addition, such Ding pieces maintain a happy balance between decorated and undecorated areas. By contrast, the ornamented Yaozhou wares of the eleventh and early twelfth century exhibit elaborate and very exuberantly carved floral decoration that wholly covers the vessel's main face (cats. 10-12). Thus, a blossoming tree peony graces the interior of one bowl (cat. 11), while the "overlapping pleats" on its exterior call to mind a chrysanthemum blossom; continuing the botanical associations, the bowl's rim is delicately notched, so that its form suggests an open blossom. In another bowl, two lotus blossoms, each accompanied by a leaf, float on rolling waves (cat. 12). In Yaozhou wares from the Northern Song period, the outlines of the design elements are deeply carved with broad, beveled strokes; because glaze pools in the resulting hollows, the wide outlines appear dark, causing the design elements to appear lighter and thus to seem to rise in slight relief. In the judiciously planned compositions, the spaces between design elements are themselves alive, punctuated by the triangular peaks and ridges that rise between the deeply outlined elements. The decoration of carved Yaozhou wares of the Northern Song period can be fairly characterized as elaborate, with many small design elements harmoniously arranged to cover the whole vessel, and as meticulously executed, with bold outlines complementing delicately combed details. Carved wares of the succeeding Jin period, typically show less elaborate decorative schemes with larger design elements (cats. 14, 15), and the carving generally is more spontaneous than meticulous (cat. 15). In addition, combing by and large disappears (cat. 14), though when employed, it often is used to describe waves that border the design rather than serving as a background to it (cat. 15). Complex designs with small design elements persisted through the late Northern Song and Jin periods but in molded, rather than carved, wares.

In the late eleventh or early twelfth century, potters at the Yaozhou kilns began to use molds not only to shape pieces but to decorate them, as well, just as did their competitors at the Ding kilns. The molds were not the double-faced press molds that in Ming times would be pressed together to form and decorate whole pieces. Rather, they were the so-called hump molds—hollow, mounds of fired stoneware that were placed on the potter's wheel; as the potter pressed prepared clay against the mold at the center of the rotating wheel, the mold shaped the vessel's interior and imparted its decoration, while the potter's hands shaped the vessel's exterior and regulated the thickness of its walls. The use of molds conveyed two distinct advantages: first, it increased efficiency of production; second, it permitted the creation of sets of vessels of identical shape, size, and decoration. Because a single mold could be used to form thousands of pieces, potters showered time and labor on their creation. Thus, molded vessels often exhibit elaborate designs with abundant small design elements, such as the Barron Collection's small bowl that features a spray of cut lotus blossoms—complemented by a single leaf and seed pod, all neatly bundled together by a ribbon tied at the bottom—set against a ground of rolling waves populated with fish (cat. 13). This bowl reveals that molded wares tend to be more strongly pictorial than carved wares; that is, they often feature limited scenes, or tableaux, rather than isolated plants or simple leaves and blossoms set against waves.

Jun Ware

Celebrated for its pale blue glazes, Jun ware was produced at a number of kilns in northern China, but particularly at kilns near Linru and, to a lesser degree, at Yuxian, both sites in central Henan Province.[13] Potters at the Jun kilns invented pale blue glazes during the Northern Song period, though Tang potters previously had experimented with bluish elements: potters at the Lushan and Huangdao kilns (in Henan Province) had enlivened their dark brown glazes with bluish-white splashes, for example, and potters at the Changsha kilns (in Hunan Province) had added copper to their high-fired glazes, achieving greenish blue hues.

Jun glazes are thick, opalescent, and translucent. Despite their color, often termed "robin's-egg blue," they are celadon glazes. In fact, apart from their prized pale blue-glazed wares, the Jun kilns also produced traditional celadon wares—stonewares with transparent, bluish-green glazes. Like all celadon glazes, the Jun glaze relies upon an oxide of iron as its coloring agent; fired in a reducing atmosphere, the glaze matures bluish-green. The Jun glaze's distinctive robin's-egg hue resulted from the spontaneous separation of the glaze into silica-rich and lime-rich glasses during firing.[14] Its opalescence arose from phase separation—that is, from the transformation of the melted glaze into an emulsion of two liquids, or phases, during the last stage of firing; during that stage, kiln temperature was maintained at, or just a little below, 1,200 degrees centigrade, after which the kiln was slowly cooled, circumstances that, in the particular Jun glaze mixture, cause phase separation.[15] The glaze's translucency, which sometimes borders on opacity, derives not only from phase separation but from the presence of numerous particles and bubbles (which are visible through a magnifying glass). Jun wares were fired in *mantou*-type kilns, which presumably were fueled with wood.

The dating of Jun ware remains vexingly problematic, as insufficient archaeological investigation has been carried out at the various kiln sites to establish their exact developmental sequence, let alone their absolute chronology. It is assumed that the kilns were active from the tenth to the fourteenth or fifteenth centuries. Well-potted vessels fully

coated with thick, monochrome blue glaze are traditionally dated to the eleventh or first half of the twelfth century (cats. 16, 17). Vessels whose pale blue glaze is embellished with lavender, purple, or deep blue splashes are assumed to date to the twelfth or thirteenth century (cat. 18); their glazes generally stop well short of the foot. Assumed to be a variety of Jun ware, large-scale flower pots and basins—types not represented in the Barron Collection—often have their blue glazes almost entirely streaked with purple; because they typically have a Chinese numeral from one to ten stamped on the base to indicate size before firing, such press-mold-produced vessels are often called "numbered Jun ware." Although some Chinese scholars attribute numbered Jun pieces to the Northern Song period, most Western experts assign them to the fourteenth or fifteenth century on both stylistic and technical grounds.[16] Obviously, the dating of such pieces remains the most vexing of all.

The moderate luster and gray lip—where the glaze thins to reveal the underlying stoneware body—point to a date of manufacture in the late eleventh or early twelfth century for the Barron Collection's exquisitely crafted dish with flat rim (cat. 16). Its underside shows five evenly spaced spur marks, or scars, left by the small "stilts" that supported the dish during firing and prevented it from fusing to the saggar as the glaze vitrified; elevated above the saggar's floor, the dish could be fully glazed, including the bottom of its foot ring. That perfect finish not only suggests a late Northern Song date for the piece but attests to the esteem in which it was held by those who made and used it. The high luster and caramel-hued lip indicate that the Collection's deep bowl was fired at a higher temperature than the previous dish, which may further indicate that it was made a few decades later (cat. 17). That its well-controlled glaze extends to the bottom of the foot ring and that it includes a variety of small, and probably unintentional, markings that add texture, imbuing the bowl with life, permit an attribution to the first half of the twelfth century.

Jun ware lacks the incised, carved, or molded decoration that is such a standard feature of many other Northern Song wares precisely because its thick, semi-opaque, opalescent glaze would obscure any such embellishment. Nonetheless, beginning in the early twelfth century and continuing at least through the thirteenth, potters at the Jun kilns often emblazoned their wares with splashes of lavender, purple, or royal blue, the colors resulting from the application of copper filings to the glaze before firing. At first, the potters seem to have sprinkled the filings to create roundels of lavender. As time progressed, they appear to have mixed the filings with water, perhaps with an admixture of glaze clay, and then applied the resulting solution to the vessels using a brush; designs so created not only possess a strongly calligraphic quality but show great variation in the hue of their copper-induced color—from lavender to purple to royal blue on the same piece—as evinced by the Barron Collection water pot (cat. 18). Its caramel lip, clouded glaze, unglazed foot ring, and linear, brush-applied band of color all support an attribution to the late twelfth or thirteenth century.

Cizhou Ware

Stretching over an arc of several hundred miles in northern China, the Cizhou system, or family, included numerous independent kilns in Shandong, Hebei, Henan, Shanxi, and Shaanxi Provinces. Although the name by which the kilns and their wares were known in Song times went unrecorded, they are today termed "Cizhou," after the name of the administrative district that is home to the first important kiln complex of this family to be

investigated in modern times. Now called Cixian, the district was named Cizhou in Song times; it lies at the very southern tip of Hebei Province.[17] Active from the late Tang through the end of the Yuan (1279-1368), and well into the Ming, the Cizhou kilns specialized in the production of stonewares with one or more coatings of underglaze slips and boldly incised, carved, or painted designs.

Potters at the various Cizhou kilns made humble wares, often taking inspiration from the aristocratic Ding and Yaozhou wares, and also from the celebrated dark glazed tea bowls made at the Jian kilns of northern Fujian Province. Untrammeled by the rarefied taste and conventions of the imperial court, Cizhou potters enjoyed a freedom of expression unknown to potters at kilns producing aristocratic wares; in a sense, the kilns became the great experimental laboratories of the day.

The Cizhou kilns varied slightly in shape and configuration from locale to locale, but all were variants on the north Chinese, single-chambered *mantou* type. Because they produced humble wares, the kilns generally employed oxidation firing, since an oxidizing atmosphere is much easier, and therefore much less expensive, to maintain than a reducing atmosphere. Many of the Cizhou kilns must have burned wood, but many others, including those at Cizhou itself, burned coal (which continues to be mined in southern Hebei Province to this day).

The Barron Collection *meiping* bottle illustrates the Cizhou technique at its most basic (cat. 24). Once it had been shaped and dried, the piece was coated with one or more thick layers of white slip, after which it was allowed to dry again and then dipped in the glaze slurry. Thanks to the warm, creamy color imparted by the pale, grayish olive glaze over the white slip, the finished bottle resembles ivory hued Ding ware on first inspection (compare cat. 6); however, examination of the bottle's lowest section, which is unglazed and unslipped, reveals that the body is not translucent white porcelain but opaque gray stoneware (the exposed portion of which fired buff). Though employing different clays and different techniques of manufacture, this humble bottle mimics the aesthetics of aristocratic Ding ware, which would have been very expensive in its day. The small mouth, bulging shoulders, constricted waist, and flaring base date this *meiping* bottle to the fourteenth century. Closely related in technique of creation, the more complex style of the very appealing undecorated white Cizhou vase with conical foot, long neck, and rolled lip indicates that it was made much earlier, during the Northern Song period (cat. 20).

Unlike the two pieces just discussed,

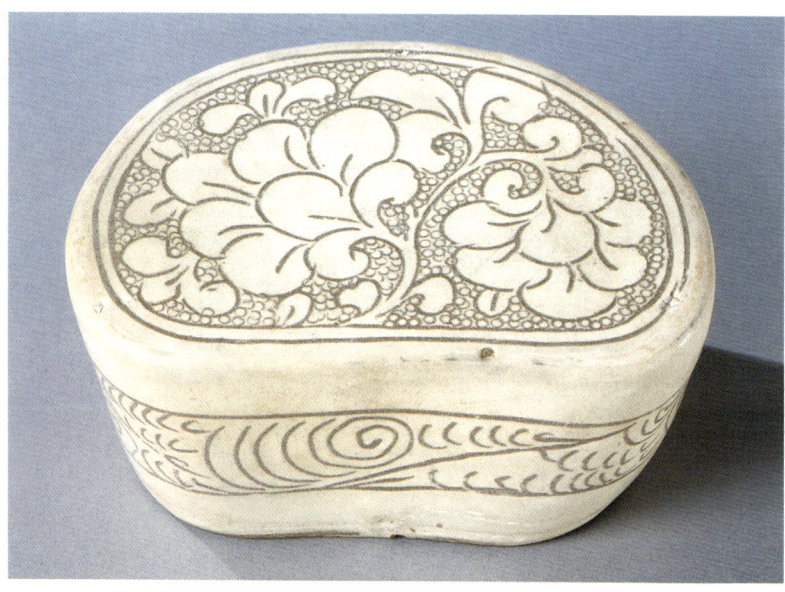

CAT. 19
CIZHOU PILLOW WITH "FISH-ROE" GROUND

most Cizhou wares feature decoration that was achieved through manipulation of their underglaze slip coatings. In fact, the Cizhou kilns were exceptionally innovative, inventing many new decorative techniques. Two bowls in the Barron Collection typify Cizhou decoration at its best (cats. 22, 23). In both instances, the bowls were covered with one or more applications of white slip; once the slip had stabilized but before it had dried, the designs were incised, carved, or combed through the slip to expose the underlying light gray stoneware body. Thus the designs rely for decorative effect not only upon slight changes in relief but upon subtle contrasts in color. The warm ivory tonality and the beveled outlines indicate that Cizhou potters took aristocratic Ding ware as their primary models; however, the exuberantly carved designs (cat. 22) and the quickly but delicately combed waves or clouds (cat. 23) doubtless derive from Yaozhou ware, indicating that Cizhou potters combined inspiration from a variety of sources (compare cats. 11 and 15). Each of these Cizhou bowls has a ring of five spur marks at the center of its floor, attesting that a similarly shaped piece was stacked on top of it during firing to maximize kiln efficiency.

The potters who made the hollow, bean-shaped pillow employed a related but slightly more complicated technique to create its decoration (cat. 19). Once he had incised the blossoming peony on its top, and had incised the band of scrolling foliage around its sides, the ceramic decorator used a small, circular punch to stamp row upon row of tiny circles in the areas surrounding the peony spray.[18] After the white slip had stabilized, the potter seems to have touched rust-colored slip into all of the intaglio lines, whether incised or stamped;[19] when the pillow had dried, it was coated all over, except for its underside, with a glaze slurry that matured pale grayish olive in firing. Ring-mat grounds had been a popular feature of Chinese gold and silver vessels crafted during the late seventh and eighth centuries; their appearance in Cizhou ware indicates that the potters not only looked to aristocratic ceramic wares for inspiration but to vessels in precious metals as well.

The Barron Collection Cizhou small bowl with dotted floral decoration showcases yet another technique of decoration; in this case, small circles of olive-brown glaze were touched onto the surface of clear glaze before firing (cat. 21).[20] This satisfying bowl shows very clearly all the layers that comprise a Cizhou vessel: lacking both slip and glaze, the unembellished lower portion displays the light gray stoneware body, while the decorated upper portion sports a clear glaze (in this case, with spots of brown) over a thick application of white slip.

Brown- and Black-Glazed Wares

During the Song Dynasty, numerous kilns garnered fame for their brown- and black-glazed stonewares, including the Cizhou kilns. In fact, most of the dark-glazed vessels in the Barron Collection were made at one or another of the many Cizhou kilns. Pieces with clear glaze over slip decoration are generically termed "Cizhou wares"; pieces made at the same kilns but with brown or black glazes are usually distinguished as "Cizhou-type wares." The dark-glazed wares were fired together with standard Cizhou wares in the same *mantou*-type kilns and in the same oxidizing atmosphere. Like other high-fired Song ceramics, the pieces were placed in saggars for firing.

In embellishing their dark-glazed Cizhou-type wares, potters at the Cizhou kilns created several new types of decoration, four of which are represented in the Barron Collection.

Cizhou-Type Monochrome-Glazed Stonewares

The earliest Cizhou-type dark-glazed wares are monochrome russet, black, tea-dust glazed vessels from the tenth century. Many Cizhou-type wares of Northern Song and Jin date are virtually indistinguishable from their dark-glazed Ding models except for their greater weight and opaque gray stoneware bodies (cats. 26, 27, 36).

Some Cizhou-type dark-glazed bowls—both monochrome and decorated—have white rims (cat. 38) that were designed to imitate the silver bands occasionally affixed to dark-glazed Ding bowls. In creating such bowls, potters immersed the piece in the dark glaze slurry and then immediately wiped the rim clean; the rim was later dipped in opaque white slip and then, following a period of drying, coated with clear glaze. The practice of banding objects with metal—lacquers and jades, as well as ceramics—to set them apart from the ordinary began at least as early as the Western Han and continued through the Six Dynasties and Tang periods, garnering renewed popularity in the Northern Song. The practice of simulating gold and silver bands on ceramic vessels also began at least as early as the Western Han, as indicated by the ochre and white bands that appear on the painted funerary earthenwares of the day. Though they attracted little interest after the fall of the Han, ceramics with bands imitating metal found renewed favor in the Northern Song, the revived interest sparked by the popularity of high-class ceramic wares with metal bands.

Cizhou-Type Wares with Mottled Glazes

Whatever their inspiration, potters at the Cizhou kilns had begun to decorate their black-glazed wares with russet flecks or splashes by the eleventh century (cats. 31-35, 37-39). Called *zhegu ban*, or "partridge-feather mottles"—a term already in use by the tenth century—such markings were created by applying iron-oxide-bearing slip to the surface of the dark glaze before firing; in some cases the markings were splashed on the surface, but in others, they were touched on with a fingertip or brush. If the glaze and slip are iron-saturated, hematite (an oxide of iron) may crystallize on the surface of the russet markings during cooling, imparting a silvery, metallic sheen. A number of Cizhou kilns produced partridge-feather glazes during the Northern Song and Jin periods; the Guantai kilns, in southwestern Hebei province, are especially well-known for such glazes.

Beginning as small flecks, partridge-feather markings quickly evolved into distinct, splash-like mottles. Early examples show an even distribution of the markings over the vessel surface, but those from the late eleventh and early twelfth centuries often display a balanced but asymmetrical arrangement; vessels from the mid- and late twelfth century typically sport a patterned arrangement of large mottles (cats. 37, 38).

Cizhou-Type Wares with Painted Decoration

In the twelfth century, potters at many Cizhou kilns began to decorate their clear-glazed vessels with underglaze designs painted in black slip on a white slip ground. Potters making dark-glazed wares soon followed suit, painting sprightly designs in russet slip on black- or tea-dust-glazed wares (cats. 40-42). Though similar in style, painted decoration on dark-glazed Cizhou wares is simpler than that on standard Cizhou wares, due to the difficulty of creating detailed scenes in dark slip on a dark glaze. The decorative scheme is typically limited to birds in flight (cat. 40) or blossoming plants (cat. 41). The abstractly

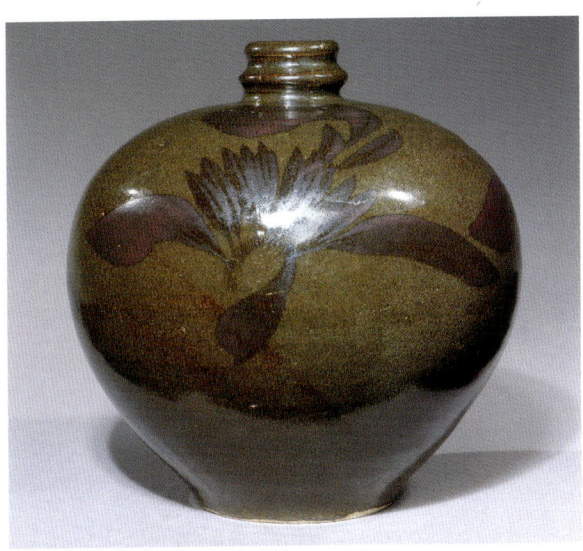

CAT. 40
SMALL-MOUTHED TEA-DUST GLAZED GLOBULAR BOTTLE DECORATED WITH BIRDS IN FLIGHT

rendered birds are usually presented from two vantage points: the head is shown in profile, its short, pointed beak immediately recognizable; the body is shown from above, reduced to a fan-shaped array of feathers that radiate outward from the spiraling neck, with a large, comma-shaped brushstroke on either side indicating the outstretched wings; the long, scrolling tail is shown partly from above, partly in profile. The painted decoration on dark-glazed vessels employs some of the most elegantly calligraphic brushwork to be found in the Chinese ceramic tradition.

Standard Cizhou wares with painted decoration only appeared in the mid-twelfth century; most dark-glazed vessels with painted decoration are thus believed to date to the late twelfth and thirteenth centuries. Although painted decoration on dark-glazed wares persisted into the fourteenth century, representational designs gave way to abstract patterns of vertical stripes in that late phase of development (cat. 42). Such easily created decorative schemes were less the result of aesthetic choice than of economic necessity. As Jingdezhen—that complex of kilns in northeastern Jiangxi province that produced the well-known *qingbai* ware (see below) and then the famous blue-and-white porcelain—began its relentless rise to preeminence in the fourteenth century, other kilns had to compete fiercely for market share. As each tried to produce quality goods at the lowest possible cost, the labor-intensive practices that had been employed in Northern Song and Jin—and that gave pots of those eras their characteristic sophistication—typically fell victim to new practices that promoted rapid production.

Cizhou-Type Wares with Ribbed Decoration

Applied in imitation of the relief ribs on lacquer and silver, white ribs were first used on ceramics during the Tang dynasty, mainly to segment the interiors of bowls and other open form vessels. They were applied sparingly to the exteriors of vessels as decoration in the tenth and eleventh centuries, and by the twelfth they had emerged as an important category of decoration in their own right. Virtually always used with dark glazes, such ribs both enliven and emphasize the forms of the pieces they ornament; in most cases they are evenly spaced (cats. 29, 30), but in others, groups of ribs alternate with undecorated surfaces, establishing geometric patterns (cats. 25, 28). In all cases, the ribs on Northern Song and Jin vessels are spaced just evenly enough to create a sense of rhythmic progression, but just irregularly enough to impart the sense of spontaneity that so readily distinguishes Song and Jin stonewares from the mechanically perfect porcelains of Ming and Qing. Mounting evidence suggests that most white-ribbed vessels were made in the twelfth and thirteenth centuries.

In rare instances, the ribs are carved directly into the moist clay of the unglazed vessel. In most cases, however, the ribs are trailings of white slip—probably the same white kaolinic slip used on standard Cizhou ware—that were extruded onto the surface in the same manner as the ribs on the Barron Collection Ding bowl (cat. 7). The whiteness of the slip contrasts with the light gray of the body clay (cats. 25, 29, 30). The ribs are triangular in section and they taper to a point at the lower end, the result of reduced pressure on the extruder during application (cat. 30).

Qingbai Ware

A number of kilns in Jiangxi, Fujian, and Anhui Provinces produced *qingbai* and *qingbai*-type wares during the Song dynasty. The names *qingbai* and *yingqing*—the modern designations that are used interchangeably for these wares—refer not to the locales where the kilns were located but to the general appearance of the wares.[21] Thus, *qing*, the first syllable of *qingbai*, means "pale bluish-green," a clear reference to the sky-blue glaze, while *bai*, the second syllable, means "white," an apt description of the pure white porcelain body. *Ying*, the first syllable of *yingqing*, means "shadow" and *qing* again means "pale bluish-green"; correctly translated as "shadow blue," the term accurately characterizes the general appearance of the wares.

The best known of the kilns that produced *qingbai* ware are located in northeastern Jiangxi Province, near Jingdezhen.[22] Wares made at Jingdezhen and at kilns in neighboring areas are categorized as *qingbai* or *yingqing* ware; ceramics of similar appearance made at kilns in other provinces are generally distinguished as *qingbai*-type or *yingqing*-type wares.

Still active today, the kilns at Jingdezhen claim a history longer that of any others in Chinese ceramic history. During the winter months, Han-Dynasty farmers there made humble ceramics for local consumption to supplement their incomes. By the Tang dynasty, full-time potters were making passable imitations of Yue and other aristocratic wares. The kilns came into their own during the Five Dynasties and Northern Song periods, thanks to their invention of *qingbai* ware, which not only enjoyed widespread usage in China but served as an important trade ware, exported to Japan, The Philippines, Indonesia, and other Asian countries. In addition, *qingbai* ware, with its translucent, sugar-white porcelain body and its watery, transparent, sky-blue glaze, would become the foundation for the later Chinese ceramic tradition. That is, with but little modification, it served as the foundation for the colorful blue-and-white porcelains from the fourteenth century onward, and, subsequently, for the brilliant enameled porcelains of the fifteenth and later centuries.

Probably inspired already in the Han Dynasty by the glazed stonewares made in the Yue region, potters at Jingdezhen adopted the same kind of kilns that the Yue potters used to fire their wares; that is, since earliest times potters at the Jingdezhen kilns have relied upon dragon kilns for firing their wares. From Song times onward, some kilns there have employed a variant of the dragon kiln known as a "chambered dragon kiln." Kilns of that variant type comprise a series of linked, hillside chambers rather than a single, continuous, hillside tunnel; the advantages of the chambered, over the standard, variety of dragon kiln are more a matter of degree and convention than of major substance. Like the Yue kilns, those at Jingdezhen were fueled with wood. The icy coldness of the finished ceramics' pale blue glazes attest to the potters' technical proficiency in maintaining a strongly reducing atmosphere. That reduction firing caused iron impurities in the exposed white porcelain clay to form a thin orange skin during firing.[23]

The kilns at Jingdezhen flourished for many reasons. First, the region has seemingly

unlimited deposits of kaolin and petuntse, the two clays necessary for making translucent, hard-paste porcelain. Second, it has abundant forests that supply the firewood required to fuel the kilns. Third, it is near Lake Poyang, which connects to the Yangtze River, which, in turn, intersects the Grand Canal and then flows into the East China Sea, ensuring a viable, dependable, and relatively safe means of distributing the finished ceramics to China and the rest of the world. Fourth, over many centuries, successive generations of highly inventive potters there developed ever more sophisticated techniques for making and decorating ceramics—ceramics of the highest aesthetic and technical quality—techniques that they passed along to their successors. Fifth, the potters—the ceramic decorators, in particular—had a superb understanding of their clients' needs, tastes, and desires, so that they seemingly always were able to create ever-new and appealing designs that held their clients in thrall. Sixth, the potters who operated the factory-like kilns, effectively deployed their highly specialized labor force in an assembly-line fashion, so that the kilns were able to produce wares as efficiently as possible, giving them a tremendous market advantage. Seventh, as Jingdezhen began to prosper in the Southern Song and Yuan periods, potters left other kilns to seek work at the expanding kilns there; thus the kilns could draw upon a talented pool of trained, skilled potters to make the ceramics necessary to meet the ever-increasing demand.

The Barron Collection includes seven exquisite examples of *qingbai* wares, all from the Northern Song period (cats. 43-48). Although potters at Jingdezhen modeled their earliest pieces on Yue ware, by the Five Dynasties and Northern Song periods—when they created *qingbai* ware—they looked for aesthetic inspiration to Ding ware (compare cats. 5-7), the ceramic ware most favored at the imperial palace in the tenth and eleventh centuries. Like tenth-century Ding ware, the earliest *qingbai* porcelains are undecorated, relying upon taut forms and beauty of glaze for aesthetic appeal (cats. 43, 44). The small water pot's extraordinarily thin walls show to advantage the delicately hued glaze, which appears slightly darker where it pools, as around the foot ring (cat. 43). The *meiping* bottle (cat. 44) features a beveled lip, indicating that the vessel—which probably was intended for wine but which conceivably could have contained vinegar, oil, or soy—was not originally outfitted with a ceramic cover. Rather, the bottle would have been stoppered with a wooden dowel wrapped with cloth, the ancient equivalent of a modern cork; a small cloth might have been draped elegantly over the ensemble's top to conceal the stopper. Perhaps mimicking a silver form, ceramic bottles of this shape seem first to have been made at the Yue kilns in the tenth century; they subsequently were made at a number of kilns.

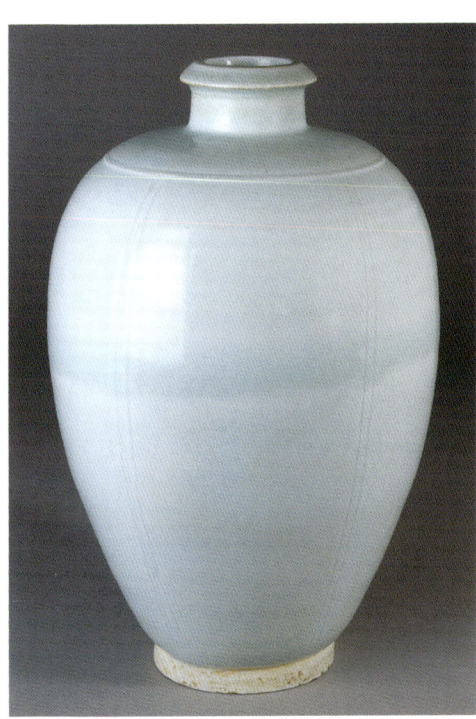

CAT. 44
LARGE QINGBAI BOTTLE OF MEIPING SHAPE

Following the lead of their contemporaries at the Ding kilns, potters at Jingdezhen not only notched the rims of their *qingbai* bowls but, in the eleventh and early twelfth centuries, embellished them with incised and carved floral

decoration (cats. 45, 46). The two superbly colored bowls in the Barron Collection even rely upon the same beveled outlines as their Ding models to describe the floral designs; as in other Northern Song wares, details were sometimes incised with a comb and the backgrounds occasionally textured with a roulette wheel. The very same qualities inform the small *qingbai* trumpet-mouthed vase, which rests on a truncated conical base fluted to resemble an inverted blossom (cat. 47). Better than any other examples, the Barron Collection's two subtly lobed dishes showcase the watery *qingbai* glaze (cat. 48). Perfectly potted and fired, the eight-lobed dishes simulate open blossoms, their notched rims and trailed ribs separating one petal from the next (compare cats. 6, 7). The dishes' basic form, like their decoration, derives from Ding ware; however, Ding examples of this shape typically lack foot rings, resting instead directly on their flat bases.

Longquan Ware

Named for the area they inhabit in southwestern Zhejiang Province, the Longquan kilns began production in the third century, during the short-lived Three Kingdoms period (220-265) that followed the collapse of Han in 220.[24] Although their period of greatest technical and aesthetic refinement came during the Southern Song period, they persisted through the Yuan Dynasty and into the Ming and Qing Dynasties; in fact, a few kilns there are still active today. Like those at Jingdezhen, the Longquan kilns concentrated on the production of humble, Yue-type wares, for local distribution, during the early phase of their development, that is, from the Three Kingdoms through the Tang and Five Dynasties periods. Also like those at Jingdezhen, they emerged from shadow in the Northern Song period, following the decline of the Yue kilns in the eleventh and twelfth centuries. Mature, Southern Song Longquan celadon wares feature thickly applied, semi-opaque glazes of cool bluish-green hue over dove gray stoneware bodies. The jade-like glazes' semi-opacity results from the presence of numerous tiny bubbles and particle inclusions, just as it does in the northern Chinese, robin's-egg blue Jun glazes. Because such glazes would obscure incised, carved, or molded decoration, many Longquan celadons are unornamented, relying on precisely defined forms and perfectly hued glazes for aesthetic appeal. However, pieces with more transparent glazes, such as those made during the Northern Song period and then again in the Yuan and Ming periods, sometimes sport incised, carved, or appliqué decoration.

Taking the Yue kilns as their model, Longquan potters early on established the dragon kiln as their standard. Like their contemporaries at the Yue and Jingdezhen kilns, they burned wood to heat their kilns and they practiced reduction firing. The latter enabled the potters to achieve glazes of cool bluish hue; it also accounts, as it does with *qingbai* wares, for the orange skin that forms on any exposed body clay during firing.

The Barron Collection's seventeen examples of Longquan celadon ware range from the Northern Song through the Yuan or early Ming period (cats. 49-63); the vast majority are mature examples dating to the Southern Song period. Perhaps inspired by a silver vessel, the small box with flat cover has a beautifully colored but clear, transparent glaze that reveals the incised and carved floral decoration it covers (cat. 49). Unique to the Longquan kilns, this interpretation of form, together with the clear glaze and incised floral decoration, dates this very satisfying piece to the Northern Song period. The similar glaze and decorative technique suggest that the covered jar with knob in the form of a small, pear-shaped vase (cat. 50) also dates to the late Northern Song period, or possibly to the early years of the Southern Song.

All undecorated and all from the Southern Song period, the conical bowl (cat. 56), the dish with flattened rim (cat. 51), and the small bowl with indented lip (cat. 59) show the mature Longquan glaze at its finest. Their proportionately small foot rings indicate that the conical bowl and the small bowl with indented lip were done late in the period. The brushwasher with everted lip also shows the Longquan glaze to great advantage (cat. 52). A rare shape that doubtless derives from a metal prototype, this brushwasher in fact is arguably the single most important piece in the Barron Collection, as it possesses every desirable feature—rare form appealingly interpreted, lustrous glaze of exquisite hue, and near-perfect condition.

Even though most Longquan celadons are undecorated, some incorporate a panel of ascending lotus petals around their exteriors. During the Northern Song period, such friezes were incised or carved and their petals were further enlivened with parallel combed lines (cats. 49, 50); by contrast, those from the Southern Song rise in subtle relief, sometimes molded, sometimes carved (cats. 53, 54, 58). A feature typical of tenth-century Yue ware vessels (compare cat. 4), lotus friezes originated in Chinese gold and silver bowls made in the late seventh and early eighth centuries.[25] The popularity of such decoration persisted into the Yuan dynasty. Such thirteenth- and fourteenth-century examples tend to be of squat form, their foot rings very small in proportion to their mouths (cat. 61); in addition, their ascending lotus petals are often outlined, in contrast to those of Southern Song date, which seldom are outlined. Carved quickly and spontaneously, the outlines sometimes follow closely the petal forms they accentuate, sometimes not. The orange skin assumed by the exposed body clay during firing is clearly visible at the bottoms of the foot rings of these several bowls.

A rare Southern Song Longquan vessel with transparent glaze over carved decoration, the dish in the form of a six-petaled mallow blossom derives its unusual shape from lacquerware, the most expensive, and thus the most desirable, material at the time (cat. 55). The combination of notches and indentations around its rim, not to mention its curving petal edges, readily distinguish this dish from related blossom-shaped bowls and dishes of Northern Song date, which generally are of less complex form (compare cats. 5, 7, 48).

During the Southern Song and Yuan periods, potters at the Longquan kilns shaped some of their pieces to resemble ancient bronze ritual vessels and ceremonial jade implements (cats. 57, 62), following the lead of the Hangzhou-based *guan* kilns, which made wares for the imperial palace. The Barron Collection's tripod censor, for example, emulates the form of

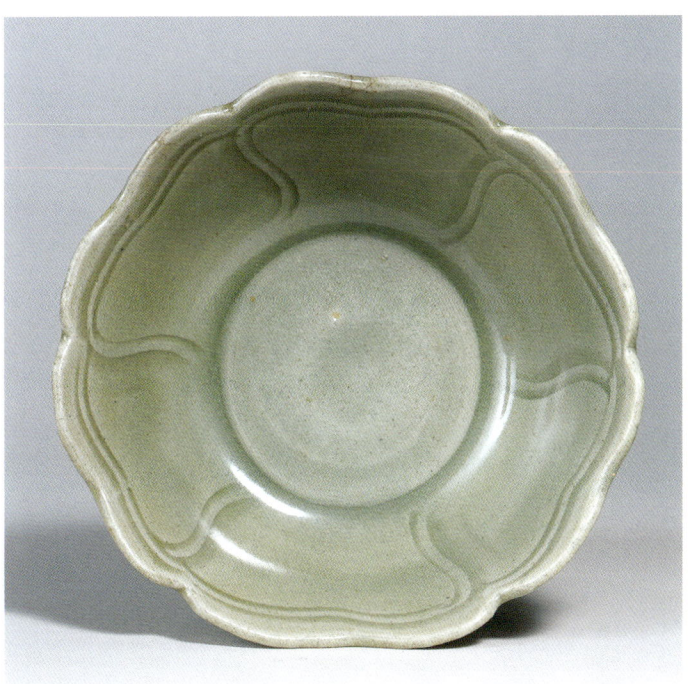

CAT. 55
FLOWER-SHAPED LONGQUAN BOWL

27

a Shang- or Zhou-Dynasty *liding* cauldron, a bronze vessel that in antiquity was used to boil millet for use in ceremonies honoring the spirits of deceased ancestors (cat. 57). Probably intended for flowers, the two arrow vases imitate the secular bronze *touhu* vessel, which served as the target in games of pitch pot (cat. 62). Akin to the interest in the art and architecture of ancient Greece and Rome on the part of Italian Renaissance artists, this turn to the past for inspiration would become a hallmark of later Chinese culture.

Very late in the South Song or early in the Yuan Dynasty, Longquan potters realized that they could decorate their wares with appliqué elements. In creating the Barron Collection dish with relief decoration of two fish swimming on its water hued floor, for example, the potters first turned the piece on the potter's wheel, aided by a hump mold (cat. 60); following a period of drying, they dipped the dish in the glaze slurry, after which they applied the two fish, which had been molded from the same light gray stoneware clay as that used for the body. Once the fish were in place, the potters poured a bit of the glaze slurry over them. Glaze typically covers the appliqué elements, which almost always represent fish, on such pieces made early in the Yuan period; by contrast, the appliqué elements of related pieces created later in the Yuan—that is, in the fourteenth century—are often left unglazed, so that they fire orange or even brick red. In addition, in those later pieces, the repertoire of appliqué elements expanded to include not only fish but dragons, geese, clouds, and blossoms.

Late in the Yuan Dynasty, potters at the Longquan kilns returned to the carved designs and clear transparent glazes that had been their mainstay in the Northern Song period (compare cats. 49, 50). Imitating the style, if not the colors, of contemporaneous blue-and-white porcelains made at Jingdezhen, Longquan potters of the late Yuan and Ming embellished their vessels with scrolling floral designs, which they arranged in horizontal registers. Thus, the Barron Collection *meiping* bottle boasts four registers of boldly carved decoration: a tall frieze of ascending lotus petals at the bottom, a principal register of scrolling lotus blossoms around the middle, a subsidiary band of scrolling clouds on the shoulder, and a narrow border of descending petals at the base of the neck (cat. 63). With its small neck, broad square shoulders, constricted waist, flaring foot, and prominent base, this bottle's form not only places it squarely in the late Yuan to early Ming period but clearly distinguishes it from *meiping* bottles made in the Song Dynasty (compare cat. 44).

Conclusion

Most of the famous kilns that produced the celebrated Song ceramics either ceased production after the Yuan or turned to the manufacture of light-colored wares in imitation of the newly popular porcelains made at Jingdezhen. The old kilns fell victim not only to the success of the Jingdezhen kilns but to the new taste that arrived with the Ming, a taste for the preferred porcelains with pictorial designs boldly painted in bright colors and vigorous brushwork. The new enthusiasm for the bold and colorful prompted the turn from brown and black lacquer, favored in the Song, to the cinnabar lacquer popular in Ming and Qing, as it doubtless also sparked the demand for articles in brilliantly hued cloisonné enamel. In the final analysis, the Yuan dynasty proved a major watershed for all Chinese art—even painting saw the literati style supplant the naturalistic Song style, with expression of the artist's ideas, feelings, and personality taking precedence over representation.

In assessing the rapid acceptance of Jingdezhen porcelains in the early Ming, it should be remembered that until potters at Jingdezhen mastered the techniques of firing cobalt

blue and copper red in the fourteenth century, high-fired ceramics were limited in color to white porcelains, to celadon-glazed stonewares, and to brown- and black-glazed stonewares, the celadons and dark wares deriving their colors from compounds of iron. Once potters at Jingdezhen perfected the technique of painting in overglaze polychrome enamels in the fifteenth century, their clients no doubt found the limited glaze palette of Song and Jin too austere and the dark-glazed wares, in particular, too somber. With their taste for the bright and colorful, Ming clients seem to have been only to happy to abandon the old for the new.

Chinese connoisseurs of the Ming and Qing Dynasties prized the "five great Song wares"—Ding, Jun, Ru, Guan, and Ge—and they occasionally showed interest in Yue and Longquan wares, so that examples of those wares survived above ground in private collections; however, those same connoisseurs and collectors showed little interest in Yaozhou ware and no interest at all in *qingbai* or Cizhou ware. Japanese collectors traditionally valued Chinese ceramics, particularly the non-aristocratic wares, so many of the ceramics less esteemed by the Chinese were preserved in Japanese collections. Still, widespread acceptance of all Song ceramics, humble and aristocratic alike, is a twentieth-century phenomenon; in fact, broad-ranging collections like the Barron Collection did not exist—indeed, could not have existed—anywhere in the world before the twentieth century.

 1. Cixi is approximately sixty-five miles east southeast of Hangzhou, the provincial capital, and about thirty miles northwest of Ningbo, the ancient port city.
 2. The number of Yue kilns in the Shanglinhu area is great both because of large-scale ceramic production over the thousand-year period and because of the relatively short life span of a stoneware kiln. Depending upon the firing temperature (characteristically greater than 1,100 degrees centigrade) and upon the number of firings per year (typically two or three), a stoneware kiln has a useful life of only thirty to fifty years, after which its bricks begin to crack and disintegrate due to the stresses of expanding and contracting during firing. Once deterioration began, a kiln traditionally was abandoned and a replacement built nearby.
 3. Celadons are called *qingci* in Chinese. The first syllable of the compound means "pale bluish-green," and the second "high-fired ceramic ware"; the term is correctly translated as "pale bluish-green-glazed stoneware" or "celadon-glazed stoneware." Believing they are using a term more closely related to the East Asian one, a number of Western scholars recently have begun to translate *qingci* as "green-glazed ware"; such usage is to be lamented, as it refers neither to the body's high-fired nature nor to the bluish component of the bluish-green glaze. In fact, "green-glazed" is the proper translation of the Chinese *lüyou*, which refers to the lead-fluxed, emerald green glaze of Han and Tang earthenwares made for funerary use. The mistaken translation of *qingci* as "green-glazed ware" has led some beginning students and novice collectors to confuse the celadon and lead-fluxed, green-glazed traditions, mistakenly assuming that the former evolved from the latter. Thus, the old term "celadon," if properly explained, remains the better translation, as it readily distinguishes the traditions. The correct translation into English of *qing* ["light bluish-green," "pale bluish green," "shadow blue," 'bice," etc.] has concerned several linguists and historians; see, for example, Edward H. Schafer, "Blue Green Clouds," *Journal of the American Oriental Society*, vol. 102, no. 1 (1982), pp. 91-92.
 4. For an example of a ninth-century, Yue celadon ware bowl of *mise* type, see Xiaoneng Yang, ed., *The Golden Age of Chinese Archaeology: Celebrated Discoveries from the People's Republic of China*, exh. cat., National Gallery of Art (Washington, D.C., 1999), pp. 482-83, no. 167.
 5. Chinese silversmiths of the Tang dynasty often modeled their vessels on forms that occur in nature; with notable exceptions, potters and lacquer artists seem to have followed suit only the Five Dynasties period.
 6. Robert D. Mowry, *Hare's Fur, Tortoiseshell, and Partridge Feathers: Chinese Brown- and Black-Glazed Ceramics, 400-1400*, exh. cat., Harvard University Art Museums (Cambridge, Mass., 1996), p. 102, no. 12.
 7. Robert D. Mowry, *China's Renaissance in Bronze: The Robert H. Clague Collection of Later Chinese Bronzes, 1100-1900*, exh. cat., Phoenix Art Museum (Phoenix, Ariz., 1993), p. 64, no. 11.
 8. Quyang is roughly one hundred thirty miles southwest of Beijing and about forty miles north northeast of Shijiazhuang, the provincial capital.
 9. Neiqiu is about two hundred fifteen miles southwest of Beijing and approximately fifty miles south of Shijiazhuang, the provincial capital.
 10. The area is ten to fifteen miles southwest of Tongchuan.
 11. Just to the north of Yaozhou itself, Huangpu is about ten miles southwest of Tongchuan. Although it

is read *bao* in standard Mandarin Chinese, the second character in this proper noun is read *pu* in certain place names in Shaanxi province, using the local dialect. Thus, the site name is correctly transliterated as *Huangpu* rather than as *Huangbao*, as it has been rendered in some recent English-language publications.

12. A basic problem in kiln design is the same as a basic problem in fireplace design: How to force the fire's heat to radiate outward, through the chamber, rather than simply escaping up the chimney with the smoke. The problem is easily solved in the dragon kilns: because such hillside kilns are inclined, the heat and smoke pass naturally through the entire length of the firing chamber in order to reach the chimney. In that sense, the dragon kiln's firing chamber is but a passageway from the fire box to the chimney; because that conduit is inclined, the heat and smoke naturally rise through it, their movement hastened by the draft created by the tall chimneys. Problems with the domed *mantou* kilns are more complex: how to force the heat to radiate throughout the firing chamber instead of merely rising to the top and then remaining there; more importantly, how, in a conventional *mantou* kiln, to prevent the heat from immediately escaping with the smoke through the chimney, which traditionally rose from the dome's top. In that context, the new design employed at the Yaozhou kilns was both innovative and ingenious.

13. Linru is approximately forty-five miles southeast of Luoyang. Yuxian is about thirty five miles east of Linru and about seventy-five miles southeast of Louyang.

14. Shelagh J. Vainker, *Chinese Pottery and Porcelain from Prehistory to the Present* (New York, 1991), p. 104.

15. Ibid., p. 105.

16. See Robert D. Mowry, "Foliate Flower Pot and Basin" in James Cuno et al., *Harvard's Art Museums: 100 Years of Collecting* (Cambridge, Mass., 1996), pp. 58-59.

17. Cixian is about twenty miles south southwest of Handan and approximately one hundred twenty miles south of Shijiazhuang, the provincial capital; it lies roughly three hundred miles southwest of Beijing.

18. Textured grounds of this type are variously termed "ring-mat grounds," "ring-punched grounds," and "fish-roe grounds."

19. The technique employed to apply the rust-colored slip awaits explanation. Although many possible techniques have been suggested, none seems to adequately explain the actual results, let alone the imperfections (portions of stamped circles without rust slip, for example). In addition, in their efforts to replicate wares with this type of decoration, modern Chinese potters have tried virtually all of the suggested techniques, with only disappointing results. In most instances, either the suggested techniques fail to give the desired result or they work but seem too cumbersome—that is, too labor intensive and thus too expensive—to have been employed at kilns producing humble, low-cost wares; in other instances, direct visual examination of original ceramics of this type reveals that some of the suggested techniques of decoration simply do not accord with reality.

20. Alternatively, it is possible the dots were created by daubing brown slip on the white slip ground before the glaze was applied. However, their thickness and translucency suggest that the dots were achieved by touching brown glaze on the surface of the clear glaze before firing.

21. As it was not recorded, the name used for these wares in the Song Dynasty remains unknown.

22. Due east of Lake Poyang, Jingdezhen is approximately ninety miles northeast of Nanchang, the provincial capital; it is about two hundred eighty miles southwest of Shanghai.

23. As they are typically subjected to oxidation firing, north Chinese wares often exhibit a tan or buff skin on their exposed body clay, rather than the bright orange skin of *qingbai* ware, which results from strong reduction firing. In fact, due to oxidation firing, the exposed bodies of both Ding and Cizhou wares often lack any discernable skin (see cats. 6, 7, 21). However, the exposed stoneware surfaces of northern wares fired in a reducing atmosphere may mature orange, as Jun ware sometimes does, depending upon the chemical composition of the clay.

24. The city of Longquan is about one hundred sixty miles southwest of Hangzhou, the capital of Zhejiang Province. Numerous kilns surround the city, with great numbers concentrated in areas to the northeast and southwest of the city. In fact, hundreds of ancient kilns appear in an area, approximately eighty miles long, that stretches from Lishui (in the northeast) through Longquan to the border of Fujian Province (in the southwest). Lishui lies roughly fifty-five miles to the northeast of Longquan.

25. For a brief discussion of the evolution of such lotus friezes, see Robert D. Mowry, "Koryo Celadons," *Orientations*, vol. 17, no. 5 (May 1986), pp. 32-37.

Catalogue

1.
SMALL YUEYAO COVERED BOX
Five Dynasties period, 10th century
Yue kilns, Zhejiang province
D. 7.5 cm (3 in.)

An olive-green glaze cloaks this spherical vessel. The cover, which forms the upper half of this fruit-shaped box, is deeply carved with a design of overlapping petals and is topped by a stem finial. The lower portion of the box is undecorated, except for an incised line encircling the rim. On the base there is an irregular ring of rough, whitish spur marks. The marks of the small pads of fire-clay that separated the two sections of the box during firing are visible on the rims.

Renowned for their jade-like appearance, Yue wares from the kilns of Zhejiang province reached their peak during the tenth century, although production continued well into the Song. During this time, Yue wares and related celadons were extremely popular. Lesser wares from these kilns were among the earliest ceramic exports to Southeast Asia and the mid-East. The finest pieces from the Yue kilns were the first official Chinese ceramic ware, commissioned by the local Wu-Yue court, and in the tenth century served as tribute wares to the Northern Song court. Among the popular products of the kilns were small spherical boxes, many decorated with lotus petals or shaped like fruit. Excavations in Zhejiang province have unearthed several similarly shaped boxes, one found at Shangyu xian in 1978.[1] Other closely related boxes are in the collections of the Fitzwilliam[2] and Shanghai Museums.[3]

1. Illustrated in Feng Xianming et al., eds. *Zhongguo Taoci 4: Yueyao* (Shanghai, 1983), no. 201.
2. See Margaret Medley, *T'ang Pottery and Porcelain* (London and Boston, 1981), pl. 109, p. 114.
3. See Wang Qingzheng, ed., *Yue Ware: Miseci Porcelain* (Shanghai, 1996), no. 44.

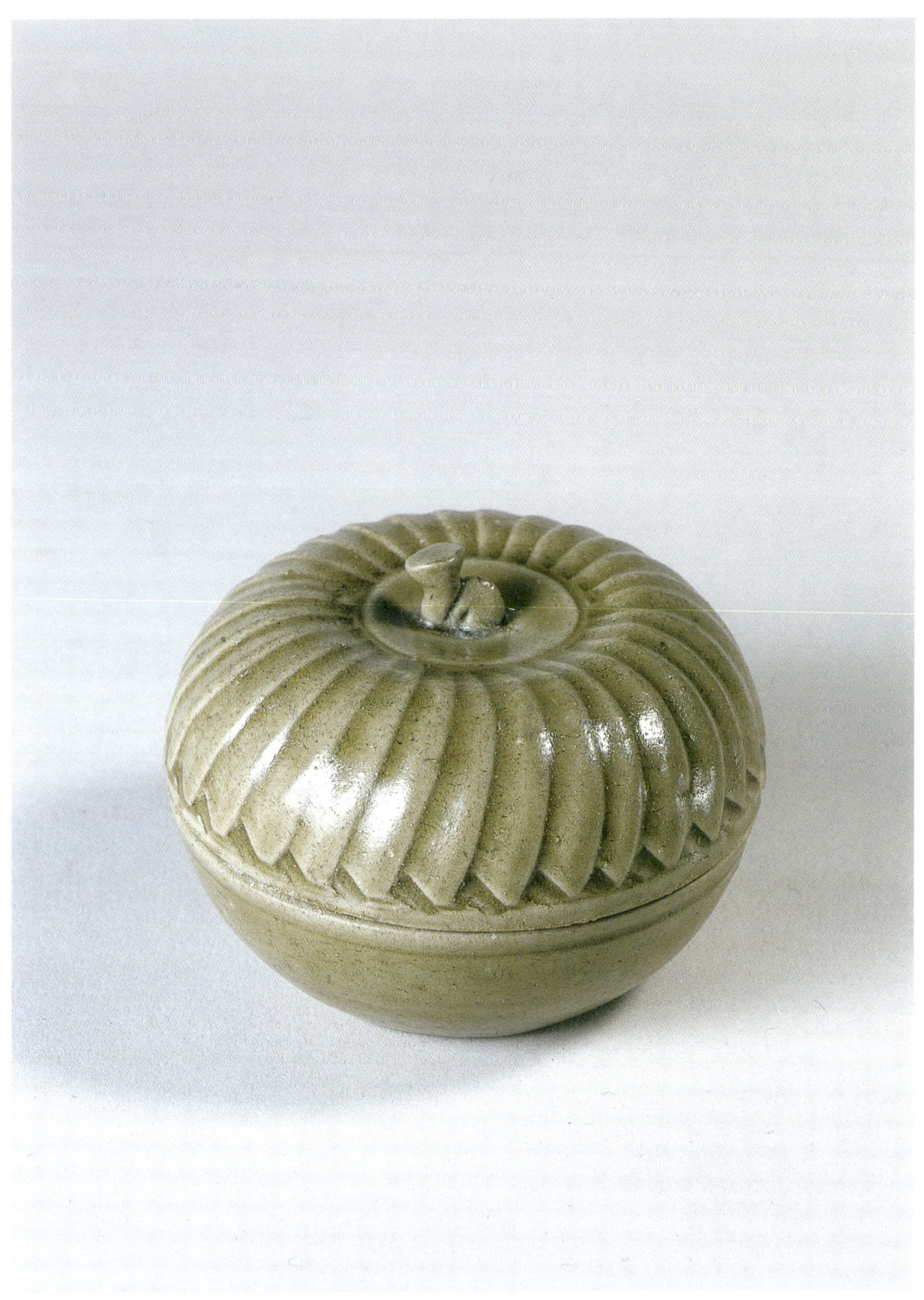

2.
YUEYAO CUP STAND
Early Northern Song Dynasty, 10th century
Yue kilns, Shanglinhu region, Zhejiang province
H. 6.1 cm (2 1/4 in.); D. 12.6 cm (5 in.)

Standing on a high, splayed foot lobed into six segments, each pierced with a trefoil design, this cup stand features a central pedestal carved with inverted petals. The pedestal's flat surface, which is surrounded by a raised lip, is incised with a freely rendered floral design, encircled by waves. The wide, surrounding disk-shaped flange has a six-lobed rim which is carved and incised with a wave design. The stand is covered with a bright olive-green glaze that is finely crackled in some areas. There are whitish spur marks on the base.

With the increased popularity of tea-drinking during the Tang dynasty, new utensils, such as cup stands, were devised. Functioning much as elaborate saucers, cup stands were used as a support upon which to place a cup while drinking.[1] During the Tang and Northern Song periods, cup stands were created in a variety of media, including silver, other metal, lacquer and ceramic wares. Yue ware cup stands of this type are relatively rare, although a similarly conceived example is in the collection of the Ashmolean Museum,[2] and another, with a sleeker profile to the central pedestal and no piercing at the foot, was excavated in 1979.[3] Despite their present scarcity, this type of Yue cup stand provided the model for Korean celadon cup stands of the twelfth century.[4] A number of *qingbai* cup stands also feature six lobes and pierced a trefoil motif on the high foot.[5]

1. See Mowry, *Hare's Fur*, no. 12, pp. 102-03 for the early history of the cup stand.
2. Illustrated by Mary Tregear, *Catalogue of Greenware in the Ashmolean Museum* (Oxford, 1976), no. 142, and by Medley, *T'ang Pottery*, p. 118, pl. 113.
3. See *Chūgoku Tōji Zenshū*, vol. 4, *Yueyao* (Kyoto, 1981), no. 195.
4. See G. St. G. M. Gompertz, *Korean Celadon* (London, 1963), plates 12A, 20B and 53A. Gompertz discusses the relationship between early Koryo celadons and Yue wares in chap. 2.
5. See John Ayers, *The Baur Collection*, vol. 1, *Chinese Ceramics (with Korean and Thai Wares)* (Geneva, 1968), no. A120, as well as the pair of *qingbai* cups and stands illustrated in Gakuji Hasebe, *Sekai Tōji Zenshū*, vol. 12, *Sō* (Tokyo, 1976), p. 168, pl. 156.

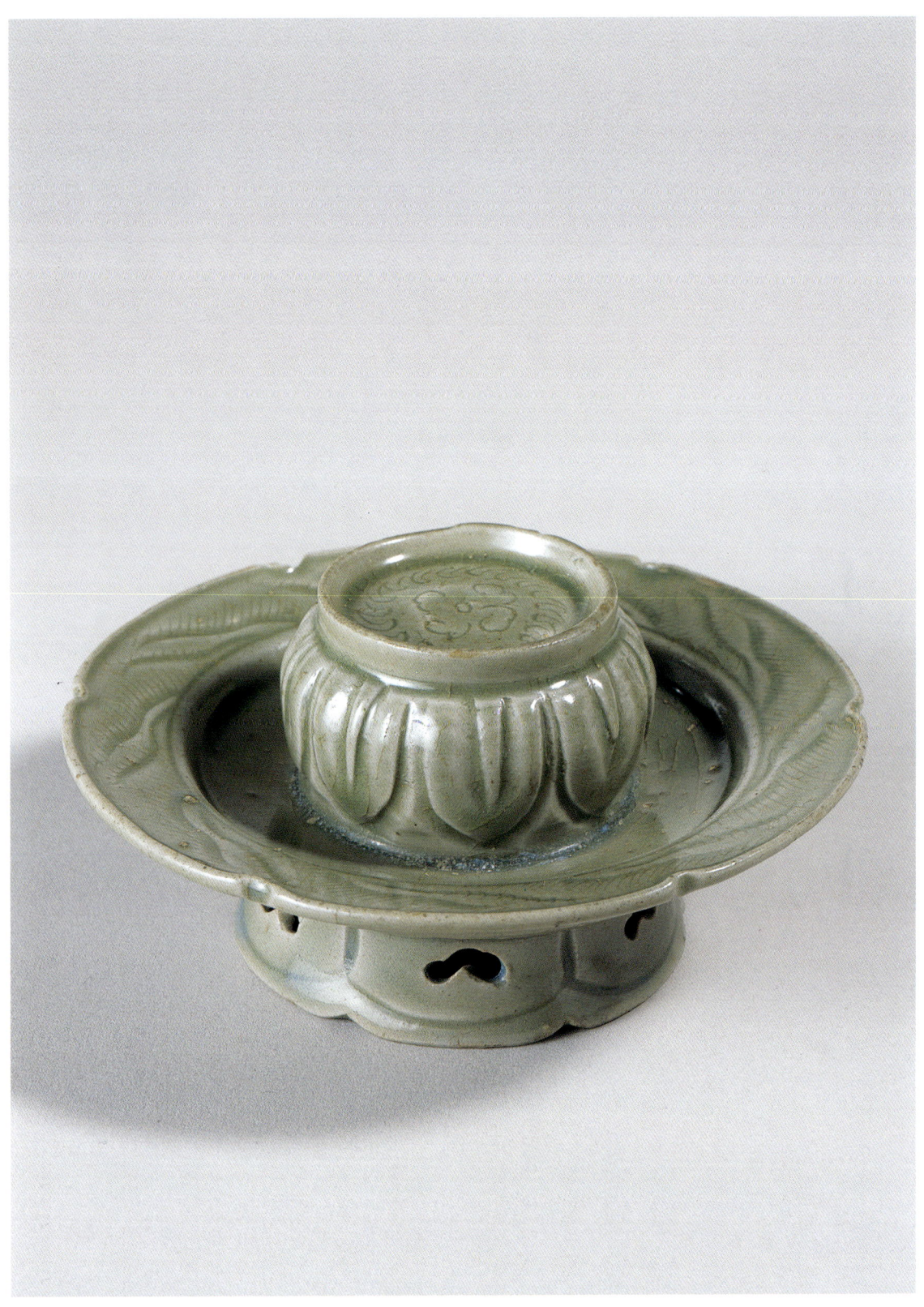

3.
LARGE YUEYAO BOX

Early Northern Song Dynasty, 10th century
Yue kilns, Shanglinhu region (possibly Huangshan shan kiln), Yuyaoxian, Zhejiang
D. 13.5 cm (5 1/4 in.)

The slightly domed cover of this round box features a molded, or carved, and incised design of confronted ducks, their necks entwined, beaks touching, and wings raised. The pair of ducks is flanked by a leafy stem connecting a lotus blossom above, a lotus leaf below, and seed pods at either side. This central composition is surrounded by a double line, which is itself encircled by a border of incised waves. The vertical sides of the cover and the bottom sections are finely incised with perfectly paired scroll-work designs. A fresh green glaze of olive tint fully covers the box, except for the rims where marks of the pads of fire-clay that separated the two halves during firing are evident. The foot is countersunk and on the base there is a ring of linear spur marks.

Engraved linear designs on Yue ware bowls, boxes and ewers derive, in part, from Tang silver motifs. Confronted or opposed ducks (and other birds) are a recurring decorative motif in Tang silver, however, ducks with entwined necks are seldom seen in silver or any other medium.[1] A *yueyao* box of the same shape and construction, recovered from the Five Dynasties- to Song period-Yue kilns at Huangshan shan in Zhejiang, features incised scroll work on the vertical sides of the cove and base identical to that on the present box.[2] The intricate decoration and bright glaze of the material recovered from this kiln site indicate its operation during one of the peaks of Yue ceramic production.

1. An example in Tang silver is illustrated by Bo Gyllensvärd, "T'ang Gold and Silver," *Bulletin of the Museum of Far Eastern Antiquities*, no. 29 (1957), pl. 6c and figure 64a, with a discussion on p. 106. A Tang pottery "pulse pillow" illustrated by Regina Krahl, *Chinese Ceramics from the Meiyintang Collection* (London, 1994), vol. 1, p. 154, no. 274 also features ducks with their necks entwined. In each of these cases the ducks are looking in opposite directions rather than facing each other, as in the Yue box under discussion.

2. Illustrated by Chin Tsu-ming, "Yü-yao hsien," in Victoria and Albert Museum/Oriental Ceramic Society Translations, no. 6, *Yüeh Ware Kiln Sites in Chekiang* (London, 1976), fig. 3 and pl. II:2. The decoration on the convexity of the cover is quite different from the Barron example.

37

4.
YUE GLOBULAR POT WITH DESIGN OF OVERLAPPING PETALS
Five Dynasties - Northern Song Dynasty, 10th century
Yue kilns, probably Shanglinhu region, Zhejiang
H. 8.9 cm (3 1/2 in.)

Resting on a high foot, this jar of almost spherical shape is carved and incised with overlapping petals. Completely covered with a pale olive-green glaze, the base has an irregular ring of whitish spur marks.

Globular jars of this type, with in-turned mouths and lacking any molding at the rim, were derived from metal prototypes, and were products of both the Yue and Ding kilns. Other similarly shaped Northern Song Yue-ware vessels featuring a carved design of overlapping lotus petals are in collections at the Museum of Fine Arts, Boston,[1] the Zhejiang Provincial Museum,[2] and the Ingram Collection, Ashmolean Museum.[3]

 1. Illustrated in Fujio Kōyama and John Pope, eds., *Oriental Ceramics, The World's Great Collections*, vol. 11, *Museum of Fine Arts, Boston* (Tokyo, 1978), monochrome pl. 103.
 2. Illustrated in Feng, *Zhongguo Taoci 4*, no. 188.
 3. Illustrated by G. St. G. M. Gompertz, *Chinese Celadon Wares*, 2d ed. (London and Boston, 1980), plate 13B, p. 56.

5.
SMALL DING BOWL
Northern Song Dynasty, 10th – early 11th century
Ding kilns, Quyang county, Hebei province
D. 14.7 cm (5 3/4 in.)

Published: Gustaf Lindberg, "Hsing-yao and Ting-yao: An Investigation and Description of Some Chinese T'ang and Sung White Porcelain in the Carl Kempe and Gustaf Lindberg Collections," *The Museum of Far Eastern Antiquities Bulletin*, no. 25 (1953), pl. 88, no. 76.

Provenance: Gustaf Lindberg, Stockholm

Of deep shape with rounded sides flaring to the lip and with a straight, thinly potted foot, this bowl is divided into six lobes by evenly spaced notching of the lip rim and vertical incised indentations on the exterior extending from each notch toward the foot. The bowl is covered with a thin ivory glaze that collects in "tear drops" above the foot. The lip rim is unglazed, showing the light porcelaneous body.

The Ding kilns, discovered in the 1940s, were active from the ninth through fourteenth centuries. One of the "five famous wares of the Song," the Ding kilns produced substantial quantities of ware used at the Northern Song imperial court.[1] Famous for their thin bodied, ivory-colored wares, the Ding kilns superseded all others during the Song, creating the best white porcelaneous stoneware in north China.

The six notches at the mouth rim of this bowl are intended to recall the shape a flower. This frequently encountered decorative motif is also seen in earlier and contemporaneous lacquer and metal wares,[1] such as the six-lobed Northern Song lacquer bowl recovered from a tomb in Anhui, which features not only the same notching technique, but also an everted lip and similar treatment of the walls.[2] Three related Ding bowls are in the Kempe collection: two small six-lobed bowls, ascribed to the tenth century,[3] and another, thought to date from the Northern Song period.[4] An eight-lobed, tenth-century Ding bowl, formerly in the Bernat Collection, features a similar foot and potting technique.[5]

1. Evidence of imperial favor for this ware is indicated by the thirty-seven pieces of Ding ware, all banded with silver and gold, excavated from the tomb of Emperor Taizong's empress (d. 1000). See Ts'ai Mei-fen, "A Discussion of Ting Ware with Unglazed Rims and Related Twelfth-century Porcelain," *Art of the Sung and Yüan* (New York, 1996), p. 111.
2. See Hefeishi wenwuguan lichu, "Hefei Beisong Ma Shaoting fuqi he zangmu," *Wenwu* 3 (1991), pl. V:1. The tomb is discussed on pp. 26-38.
3. These bowls are illustrated in Bo Gyllensvärd, *Chinese Ceramics in the Carl Kempe Collection* (Stockholm, 1964), p. 119, nos. 364 and 365.
4. See Lindberg, in "Hsing-yao and Ting-yao," pl. 66, no. 60.
5. See William Watson, *Tang and Liao Ceramics* (New York, 1984), p. 168, pl. 179.

41

6.
LARGE DING JAR
Northern Song Dynasty
Ding kilns, Quyang county, Hebei province
H. 14.2 cm (5 5/8 in.)

Provenance: H.M. Knight Collection

Standing on a low circular foot, the rounded sides of this vessel rise to form an elongated spherical body, turning in at the shoulder, where they give way to a short, slightly tapered neck. Undecorated except for a pair of incised lines encircling the shoulder, the jar is covered, largely by an ivory-tinted glaze. Unglazed areas include the lip and foot rims and portions of the interior, where the technique of swirling the glaze to cover the inside missed several areas. The unglazed portions of the vessel have fired to a pale buff color.

The unglazed mouth rim, general shape, and comparison to similarly shaped vessels, including one in the collection of the Buffalo Museum of Science[2] and another, in the late twelfth-century tomb of Yan Deyuan,[3] suggest that the Barron jar originally featured a cover. An undecorated Ding jar of similar shape, but with a rounded lip rim, is in the collection of the Victoria and Albert Museum.[4]

 1. Illustrated by Walter Hochstadter, "Ceramics of the Five Dynasties and Sung Periods," *Hobbies: The Magazine of the Buffalo Museum of Science*, vol. 26, no. 5 (June 1946): no. 88.
 2. Illustrated by John M. Addis, *Chinese Ceramics from Datable Tombs, and Some Other Dated Materials* (London, 1987), p. 28, pl. 19a. The tomb is dated to 1189.
 3. Illustrated in William B. Honey, *The Ceramic Art of China and Other Countries of the Far East* (New York, 1954), pl. 58a, and again in Kōyama and Pope, eds., *Oriental Ceramics, The World's Great Collections*, vol. 6, *The Victoria and Albert Museum* (Tokyo, 1976), monochrome plate no. 80.

7.
LARGE DING NOTCHED BOWL
Northern Song Dynasty, 11th century
Ding kilns, Quyang county, Hebei province
D. 20.3 cm (8 in.)

Published/Exhibited: John H. Seto, *Ceramics: The Chinese Legacy* (Memphis, 1984), p. 14, no. 9.

Provenance: Arnold Manthorne, Massachusetts

The slightly rounded sides of this large conical bowl emanate from a low straight foot. The segmentation of the bowl into six lobes is effected by several coordinated means: the evenly spaced notching of the lip rim, thin raised lines of slip extending from each notch to the circular medallion at the bottom of the bowl and exterior vertical lines from the lip notches to the foot corresponding exactly to the slip lines on the interior. The bowl is completely covered with an ivory-tinted glaze, except for the unglazed lip rim, which reveals the white porcelain body. The glaze collects in "tear drops," so characteristic of Ding ware, at the lower exterior of the bowl.

This bowl typifies the elegant simplicity of Northern Song Ding ware. Like many such wares, it has an unglazed mouth rim. During the Northern Song, potters at the Ding kilns began firing most bowls and dishes upside down and stacked in saggars in order to prevent warping of the thin walls and to save space in the kiln. For this firing method, the rims were first wiped free of glaze, and after firing, were banded with gold, silver or copper to conceal the unglazed rim. The metal rim also produced an attractive contrast with the creamy white glaze. Slight discoloration around the rim of this bowl evidences such banding, long since removed. A virtually identical bowl is in the Heeramaneck Collection,[1] and another, the same size and shape but with a carved lotus decoration in the well, is in the Seligman Collection.[2]

1. Illustrated in George Kuwayama, *Chinese Ceramics: The Heeramaneck Collection* (Los Angeles, 1974), p. 28, pl. 10.
2. John Ayers, *The Seligman Collection of Oriental Art*, vol. II; *Chinese and Korean Pottery and Porcelain* (London, 1964), pl. XXXI, no. D79.

45

8.
YAOZHOU LOBED BOWL
Northern Song Dynasty, 11th century
Yaozhou kilns, Huangpu, Tongchuan, Shaanxi province
D. 12 cm (4 3/4 in.)

Standing on a high, very thin foot, the walls of this bowl curve outward and upward, culminating in a deeply scalloped lip. Divided into ten lobes by vertical indentations in the sides, the overall form of the bowl resembles a flower blossom. The bowl, including the base, is covered with an olive-green glaze that has burned to a pale tan color on the foot. The foot rim is unglazed, revealing the dense, light gray body.

The Yaozhou kilns, established in northern China during the Tang period, were active through the Yuan, reaching their height during the Northern Song and Jin. Lobed bowls, such as this one, have been discovered at the Yaozhou kilns site of Huangpu, southwest of Tongchuan city in Shaanxi province.[1] One, virtually identical in size and shape to the Barron bowl has been recovered from the mid-Northern Song stratum, dating from 1023 to 1085.[2] Two other similarly lobed bowls, recovered from the same site, are assigned to the early Northern Song strata (i.e., 960-1022) and the mid- to late Northern Song strata, about 1085, respectively.[3]

Other ten-lobed Yaozhou bowls have been recovered from an earlier excavation of an undated cache,[4] and a related Yaozhou saucer, with twelve lobes and a flat base, is in the Ashmolean Museum.[5] The same shape also appears in other Northern Song ceramic wares, most notably the Ru bowl in the National Palace Museum, Taipei.[6]

The close relationship between Northern Song ceramics and lacquers is well illustrated by a number of similarly sized and shaped ten-lobed lacquer bowls bearing dated inscriptions or excavated from datable tombs. One remarkably similar bowl, both in shape and thinness, from a Song tomb near Wuxi, in Jiangsu province,[7] is inscribed on its base with a cyclical date corresponding to 1073. Found in the same tomb was the companion ten-lobed saucer, bearing an identical inscription.[8] Two other ten-lobed lacquer bowls, somewhat larger than the Barron bowl, were discovered in 1986 at the Song tombs at Hongmeixincun in the city of Changzhou in Jiangsu, and are dated to the mid-Northern Song.[9]

 1. Shaanxi sheng kaogu yanjiusuo and Yaozhouyao bowuguan, *Songdai Yaozhou Yaozhi* (Beijing, 1998), p. 135, no. 14; color plate III, no. 3. Another ten-lobed bowl with a shorter foot is illustrated by a line drawing, p. 135, no. 13.
 2. Ibid. p. 542.
 3. Ibid. p. 563.
 4. Illustrated in Shaanxi sheng bowuguan, *Yaoci Tulu* (Beijing, 1956), part I, pl. 5. Also illustrated are two lobed bowls, one stacked inside the other, see, p.1, pl. 1.
 5. Mary Tregear, *Song Ceramics* (New York, 1982), p. 115, no. 132.
 6. Ibid., p. 129, pl. 153. The Palace Museum bowl is discussed by Mowry, "Koryo Celadons," p. 24, fig. 10, in relation to a pair of ten-lobed Koryo celadon bowls and their similarly lobed, flat-based saucers, currently in the Rockefeller Collection, Asia Society, New York.
 7. Wuxi cheng bowuguan, "Jiangxi Wucheng Xingzhu Song mu," *Wenwu* 3 (1990): 19-23. The bowl is illustrated in pl. 6: 1, and on p. 19, fig. 2: 1.
 8. Ibid. p. 20, fig. 3: 1-2.
 9. Changzhou cheng bowuguan, "Jiangsu Changzhou cheng Hongmeixincun Song mu," *Kaogu* 11 (1997): 44-50. One of the lacquer bowls and its saucer is illustrated in pl. VII: 3-4.

9.
MELON-SHAPED YAOZHOU JAR
Northern Song Dynasty, 11th - 12th century
Yaozhou kilns: Huangpu, Tongchuan, Shaanxi province
D. 12.8 cm (5 in.)

Provenance: Marquis Giaquili Ferrini, Florence

The jar is of compressed globular shape with a low foot, short neck and slightly everted lip rim. The body is divided into twelve lobes by means of vertical indentations in the wall of the vessel. Both the base of the neck and shoulder of the vessel are encircled by incised double lines. An olive-green glaze covers the jar, except for an irregularly shaped area in the bottom of the interior and the footrim, which has fired to a grayish-brown color.

The Song potters' use of natural forms as sources of inspiration is once again apparent in this vessel whose shape refers to a lobed melon.[1] The popularity of this form is evident in Yaozhou and other Northern Song ceramic wares. Lobed vessels of this general size and disposition have been found in the excavations of the Yaozhou kilns at Huangpu, throughout the mid- and late Northern Song strata (1023-1127).[2] A similar lobed Yaozhou jar is in the Koger collection.[3] Very closely related, in terms of size and shape, are the melon-shaped Ding ware jars in the Meiyingtang collection[4] and the Osaka Municipal Muscum.[5]

1. This lobing technique is discussed in Mowry, *Hare's Fur*, no. 25, pp. 125-26.
2. See Shaanxi sheng, *Songdai*, p. 563, pl. 265.
3. Illustrated by John Ayers, *Chinese Ceramics, The Koger Collection* (London and New York, 1985), p. 50, no. 26.
4. Illustrated in Krahl, *Chinese Ceramics from the Meiyintang Collection*, p. 200, no. 349.
5. See Nezu Institute of Fine Art, *White Porcelain of Dingyao* (Tokyo, 1983), p. 80, no. 110. This jar is also illustrated in Osaka Municipal Museum, *Catalogue of the Osaka Municipal Museums* (Tokyo, 1980), color pl. 13c.

10.

YAOZHOU ZHADOU WITH FOLIATE RIM AND CARVED FLORAL DECORATION

Northern Song Dynasty, 11th - early 12th century
Yaozhou kilns, Tongchuan, Shaanxi
D. 14 cm (5 1/2 in.)

The vessel, which rests on a low foot, has a compressed globular body and a wide cylindrical neck flaring to a foliate lip rim. The foliations were produced by the bending over of the rim in six evenly spaced sections and by shallow notching of the interspersed upright portions of the lip. A thin line of slip extends from each of these six notches to the base of the neck on the interior of the vessel. A carved design of vertical, serrated leaves encircles the exterior of the neck. The lower, bowl-shaped portion of the vessel, is decorated with a freely carved, sketchy floral motif. The *zhadou* is covered with a translucent olive-green glaze except for the thickly potted foot rim that has fired to a reddish brown color.

The function of this distinctively shaped vessel is still open to debate,[1] although most specialists believe that it was used as a waste receptacle for wine dregs or tea leaves. First appearing in the late ninth century, the *zhadou* became an increasingly popular shape during the Song. The Yaozhou kiln-site excavations at Huangpu have yielded a number *zhadou*, clarifying the development of the form.[2] At these kilns the earliest *zhadou*, dating from the very onset of the Northern Song, featured a compressed bowl topped by a flared, unfoliated neck. By the middle of the Northern Song, this type of vessel is characterized by a more attenuated profile; both the foot and neck are tall and narrow, and the lip features a foliate rim. *Zhadou* of stouter proportion, similar in both form and decoration to the Barron example, have been found in the mid-part of the late Northern Song strata of the site (1086-1127).[3] Likewise, the mid-Song strata of excavations conducted at Huangbaozhen revealed a comparable example.[4]

Similar Yaozhou ware *zhaodou* include one found at the Jianwenmiao in Xi'an,[5] and another, in the Meiyintang collection.[6] *Zhadou* featuring related decorative motifs, but of more slender proportion, can be found in the Metropolitan Museum of Art,[7] a private Japanese collection,[8] and the Kwan collection.[9]

The *zhadou* shape, while most closely associated with Yaozhou celadons, is also known in black-glazed Northern Song wares, as evidenced by another vessel in the Barron collection (cat. 25).

1. For a discussion of the shape and its evolution in northern black wares and Yaozhou celadons, see Mowry, *Hare's Fur*, no. 60, pp. 173-74.
2. Shaanxi sheng, *Songdai*, p. 589.
3. Ibid. pl. LXVIII: 5.
4. Shaanxi sheng kaogu yanjiusuo, *Shaanxi Tongchuan Yaozhouyao* (Peking, 1965), p. 23, fig. 14, no. 1.
5. Illustrated in Shaanxi sheng bowuguan, *Yaoci Tulu*, pt. 1, no. 1, and again by Jan Wirgin, *Sung Ceramic Designs* (London, 1979), pl. 7e. In the text, p. 34, Type Nc 10, Wirgin discusses the serrated petal motif as seen in various types of Yaozhou ware.
6. Krahl, *Chinese Ceramics from the Meiyintang Collection*, p. 31, no. 412
7. Illustrated in Suzanne Valenstein, *Handbook of Chinese Ceramics*, rev. ed. (New York, 1989), p. 82, no. 76.
8. Museum of Oriental Ceramics, *Masterpieces of Yaozhou Ware* (Osaka, 1997), p. 30, no. 32.
9. Hong Kong Museum of Art, *Song Ceramics from the Kwan Collection* (Hong Kong, 1994), pp. 178-9, no. 71.

51

11.
CARVED YAOZHOU BOWL WITH PEONY DESIGN
Northern Song Dynasty, 11th century
Yaozhou kilns, Tongchuan, Shaanxi
D. 21 cm (8 1/4 in.)

Published/Exhibited: Carol H. Wood, *Art of China and Japan* (Huntsville, 1977), no. 24 and Seto, *Ceramics: The Chinese Legacy*, p. 18.

Provenance: Warda Drummond, Montreal

From a small circular foot, the walls of this shallow bowl extend outward at an obtuse angle then flare outward and upward, creating a sharply angled profile. The interior of this shallow bowl features a carved and combed design of a single large peony blossom surrounded by foliage, which is encircled by a single incised line. The floral motif is furthered by six, very small, evenly spaced notches at the lip rim, alluding to the blossom form. The bowl is decorated on the exterior with parallel vertical incisions creating a pleated effect. A dark olive-green, glassy glaze covers the bowl, pooling in the recesses of the carving. The foot rim is unglazed and burned brown in the firing.

Often seen in Northern Song ceramics, the peony was a particularly popular decorative motif in Yaozhou ware. With its numerous petals, the peony conveyed the wish for abundant wealth. Deeply carved designs, such as that seen on the present bowl, allowed for the glaze to pool in the recesses of the carving, creating a sense of depth and dimensionality. Carving and incising were common decorative techniques for the Yaozhou potter, particularly during the Northern Song.

Excavations at the Yaozhou kiln site have uncovered several such shaped and decorated bowls. The earliest excavations at Huangbaozhen (near Tongchuan city), in 1959 uncovered two sherds from bowls remarkably close in shape, form and decoration to the Barron example, in the mid-Song strata.[1] Later excavations, undertaken in the 1980s and 1990s, have revealed a similarly conceived bowl, found in the early-Northern Song strata (1023-1085) at the Huangpu kiln site, near Tongchuan city.[2]

A number of related bowls exist in collections outside of China, including somewhat smaller, but otherwise very similar bowls in the Museum Yamato Bunkakan,[3] the Museum of Oriental Ceramics, Osaka,[4] and a private Japanese collection.[5]

1. A line drawing of the decoration appears in Shaanxi sheng, *Shaanxi Tongchuan Yaozhouyao*, p. 27, fig. 16: 1. The profile is shown in a line drawing, on p. 21, fig. 13: 16 of the same publication. One of the fragments is illustrated in pl. XI: 7.
2. Line drawings of the bowl (profile and interior decoration) may be found in Shaanxi sheng, *Songdai*, p. 206, pl. 107: 1 and p. 577; the same bowl is illustrated in pl. 51: 1.
3. Illustrated in Mayuyama and Co., Ltd., *Mayuyama: Seventy Years*, vol. 1 (Tokyo, 1976), p. 121, pl. 349. Wirgin, *Sung Ceramic Designs*, p. 28 discusses the decoration and illustrates the same bowl, pl. 3k, fig. 2c.
4. Illustrated in the Museum of Oriental Ceramics, *Masterpieces*, p. 51, no. 65.
5. Illustrated in Hasebe, *Sekai Tōji Zenshū, Sō*, no. 196, p. 204.

12.

YAOZHOU BOWL WITH CARVED DECORATION OF TWO LOTUS AND WAVES

Northern Song Dynasty
Yaozhou kilns, Tongchuan, Shaanxi
D. 21 cm (8 1/4 in.)

The straight sides of this deep conical bowl rise from a small circular foot and culminate in a sharply upturned lip rim. The interior is carved with a design of two pairs of alternating elongated lotus blossoms and leaves, their stems emanating from the central concavity of the bowl. A combed and carved design of rolling waves provides the background and unifying linear elements for the composition. The bowl is covered with a translucent olive-green glaze that pools in the recesses of the carving. The base is glazed but has burned a brownish color in firing, and the foot rim is unglazed revealing the dense, light gray body.

The lotus is one of the most important and frequently encountered decorative motifs during the Song period, occurring in almost all media, including a great range of ceramic wares (see cat. 3, 4). The design of lotus and waves likewise had numerous variations and manifestations during its long history at the Yaozhou kilns, at times incorporating fish and waterfowl into the composition.[1] A sherd carved and combed with a similar design to the Barron conical bowl, but including two small fish has been excavated from the mid-Song strata at the Yaozhou kilns of Huangbaozhen.[2]

A number of bowls, related closely in design and form, are in Western and Asian collections, including the National Palace Museum, Taipei,[3] the Chang Foundation,[4] and the former collections of E.H.M. Cox[5] and the Reach family.[6]

1. See Shaanxi sheng, *Shaanxi Tongchuan Yaozhouyao*, pl. XV: 2 and 7.
2. Ibid., pl. XV: 7.
3. National Palace Museum, *Illustrated Catalogue of Sung Dynasty Porcelain in the National Palace Museum, Lung-ch'üan Ware, Ko Ware and Other Wares* (Taipei, 1974), p. 68, no. 76.
4. Chang Foundation, *Ten Dynasties of Chinese Ceramics from the Chang Foundation* (New York, 1993), pl. 19.
5. Illustrated in Sotheby's, London, *Catalogue of Fine Chinese Ceramics and Works of Art* (May 18, 1971), p. 25, no. 108.
6. See Eskenazi, Ltd., *Chinese Art from the Reach Family Collection* (London, 1989), no. 21. A detail of the design is on p. 9, fig. 3.

13.
SMALL MOLDED YAOZHOU BOWL
Northern Song - Jin Dynasties
Yaozhou kilns, Tongchuan, Shaanxi
D. 11.8 cm (4 5/8 in.)

This conical bowl rests upon a small foot, its straight walls rising outward to a slightly everted lip rim. The molded interior decoration is an intricate pattern of a lotus bouquet consisting of flowers, leaves and seed pods, their stems tied with a ribbon, set against a background of waves and flanked on either side by small fish. The exterior is decorated with parallel vertical incisions resembling pleats. The bowl, including the base, is covered with a transparent olive-green glaze. The unglazed foot rim reveals the dense gray body.

Molds were frequently employed by Song potters, including those at the Yaozhou kilns. The effect achieved by molding was similar to the carving and combing seen in the previous entries; the glaze accumulated in the recessed areas, deepening the color and emphasizing the pattern. Molding was also an efficient means of shaping and decorating pottery, since the damp clay received both its shape and design when pressed against the matrix. After removing the vessel from the mold, the potter could further embellish the design with carving or incising, in this case, adding the vertical incisions on the exterior of the bowl to create a pleating effect.

Bundled lotus, either as a single motif or in pairs and triplets appear on a number of molded conical bowls unearthed at Yaozhou kiln sites in late Northern Song strata (1086-1127).[1] The excavations at Huangbaozhen have revealed a very similar single bouquet bowl dating to the same time period.[2] Similarly conceived bowls are also present in collections outside of China, including the Museum of Oriental Ceramics, Osaka,[3] the Meiyintang collection,[4] and the Percival David Foundation of Chinese Art.[5]

1. See Shaanxi sheng, *Songdai*, p. 156, fig. 84: 5-9 for bowls featuring three lotus bouquets.
2. Shaanxi sheng, *Shaanxi Tongchuan Yaozhouyao*, pl. XIX: 2. Line drawings of this bowl can be seen in fig. 20:1 and fig. 22:1.
3. Illustrated in Museum of Oriental Ceramics, *Masterpieces*, p. 47, no. 60, this bowl has a very similar lotus bouquet with four boys clinging to the stems.
4. Krahl, *Chinese Ceramics from the Meiyintang Collection*, p. 238, no. 427.
5. This shallow bowl features three ribbon-tied bouquets of lotus and other flowers and has been illustrated by both Kōyama ad Pope, eds., *Oriental Ceramics, The World's Great Collections*, vol. 7, *Percival David Foundation of Chinese Art, London* (Tokyo, 1976), pl. 17 and Wirgin, *Sung Ceramic Designs*, pl. 10 and fig. 10b. Wirgin discusses the design on p. 42, Type No. 31.

57

14.

CARVED YAOZHOU BOWL WITH SINGLE LOTUS BLOSSOM AND LEAF DECORATION
Jin Dynasty, 12th - early 13th century
Yaozhou kilns, Tongchuan, Shaanxi province
D. 19 cm (7 1/2 in.)

This bowl has a low foot, rounded sides and a thickened, lightly grooved band around the exterior of the lip. The interior is carved with a single lotus blossom and adjacent leaf flanked by curling scroll patterns. The petals of the lotus are rounded in contour, and the blossom appears to bend, as if in caught in a breeze, imparting a sense of flowing circular motion to the composition. The bowl is covered with a translucent olive-green glaze except for the foot rim, which has burned a reddish brown color.

Like most other centers of ceramic production in north China, the Yaozhou kilns continued to operate after the Jin conquest in 1127. While there is, of course, much stylistic continuity, distinctive motifs, such as the freely carved lotus blossom and leaf seen here, can be seen in Yaozhou ware of the Jin period.

Several closely related bowls have been recovered from kiln site excavations and datable tombs. A sherd carved with this design was found among the Jin and Yuan strata at Huangbaozhen.[1] Another similarly carved bowl was found in the tomb of Dong Jijian in Shanxi which can be dated to 1210.[2]

Yaozhou bowls carved with this design are well represented in public and private collections, including the Tokyo National Museum,[3] the Victoria and Albert,[4] and the Meiyintang collection.[5] In these examples the petals of the lotus tend to be upright and pointed, rather than rounded as in the Barron bowl.

1. Shaanxi sheng, *Shaanxi Tongchuan Yaozhouyao*, pl. XXIII:8. The design also appears in a line drawing on p. 39, fig. 26: 2.
2. See *Kaogu* 5 (1979): pl. XI:3.
3. Illustrated in Museum of Oriental Ceramics, *Masterpieces*, p. 73, no. 94. This bowl is also illustrated, along with two other examples in Wirgin, *Sung Ceramic Designs*, pl. 9 a, b, c. Wirgin discusses the design, designated Type No. 20, on p. 38.
4. Illustrated in Kōyama and Pope, eds., *Oriental Ceramics, The World's Great Collections*, vol. 6, *Victoria and Albert Museum, London* (Tokyo, 1976), color pl. 30.
5. See Krahl, *Chinese Ceramics from the Meiyintang Collection*, p. 232, nos. 413-414.

15.

SMALL CARVED YAOZHOU BOWL WITH BLOSSOM AND WAVE DESIGN
Jin Dynasty, 12th century
Yaozhou kilns, Tongchuan, Shaanxi province
D. 14 cm (5 1/2 in.)

Published/Exhibited: Wood, *Art of China and Japan*, no. 26.

The rounded sides of this small bowl emanate from a low foot, and rise upward toward a plain, straight lip. The interior is carved with a sprig of leaves and a five-petalled flower surrounded by a combed design of waves. The bowl is covered by a translucent olive-green glaze, except for the base and foot rim, which have fired to a reddish brown color.

Sherds from Yaozhou kiln site excavations featuring this distinctive decoration have been found in the later strata.[1] Similar bowls with this well-known design are in the collection of the Percival David Foundation.[2] The same design is found on a series of small bowls of similar shape, but featuring an everted, grooved lip rim. Bowls of this latter type are found in the Rockefeller[3] and Meiyintang[4] collections.

1. See Mainichi Shimbusa and Nihon Chugoku bunka, *China's Beauty of 2,000 Years: Exhibition of Ceramics and Rubbings of Inscriptions in the Hsi'an Museum* (Tokyo, 1965), no. 236.
2. Illustrated in Kōyama and Pope, eds., *Oriental Ceramics, The World's Great Collections*, vol. 7, *Percival David Foundation of Chinese Art, London*, color pl. 18, and again in Tregear, *Song Ceramics*, p. 106, pl. 125. Another bowl of this type may be found in Oriental Ceramic Society, *The Arts of the Sung Dynasty* (London, 1960), pl. 53, no. 44.
3. See Denise Patry Leidy, *Treasures of Asian Art, The Asia Society's Mr. and Mrs. John D. Rockefeller 3rd Collection* (New York, 1994), p. 160, pl. 152.
4. Krahl, *Chinese Ceramics from the Meiyintang Collection*, p. 233, no. 419.

16.
JUNYAO DISH WITH FLAT EVERTED RIM
Northern Song Dynasty, late 11th – early 12th century
Jun kilns, Henan province
D. 18.5 cm (7 1/4 in.)

Heavily potted and of shallow form with rounded sides and everted rim, this dish is covered overall with a thick lavender-blue glaze that thins at the lip rim. The low foot is also glazed, and in the center of the base there is a recessed circle surrounded by five small spur marks in a circular pattern.

The term "Jun ware" actually refers to several types of stonewares with thick, opalescent, light blue glazes, which were primarily made in Henan province from the Northern Song period onward. The ware was produced at a number of kiln sites in an area once known as Junzhou, the most important of which were the counties of Yu and Linru in Henan province. The kilns originated in the Tang dynasty, and flourished during the Song and Yuan periods before declining in the fifteenth century.

The best examples of this type of ware are vessels of simple and well-proportioned shape, with fine-grained, light gray bodies, covered in an opaque pale blue glaze. The fully glazed foot ring of this dish, with five small spur marks, is typical of early twelfth-century wares. In addition to indicating that the piece was fired right side up, this attention to detail typifies the aesthetic concerns of the early twelfth-century.

A number of similar dishes, each featuring five spur marks on the base, are in private and public collections, including the National Palace Museum, Taiwan,[1] and the collection of Mrs. Alfred Clark.[2] Some Junyao dishes of this shape were fired on three or four, rather than five, spurs, while others were fired on their foot rims.[3]

1. Two very similar dishes are illustrated in National Palace Museum, *Illustrated Catalogue of Sung Dynasty Porcelain in the National Palace Museum, Ju Ware, Kuan Ware and Chün Ware* (Taipei, 1978), nos. 79-80. The second of these is also illustrated, in two views, in National Palace Museum, *Porcelain of the National Palace Museum, Chün Ware of the Sung Dynasty* (Hong Kong, 1961), p. 79, pl. 36a-b.

2. Another similar dish, from the collection of Mrs. Alfred Clark, is illustrated by Basil Gray, *Early Chinese Pottery and Porcelain* (London, 1953), pl. 84.

3. For an example of the latter type, see Ayers, *The Seligman Collection*, pl. XXXIII, no. D91.

17.
JUNYAO DEEP BOWL
Late Northern Song Dynasty, first half of the 12th century
Jun kilns, Henan province
D. 14.5 cm (5 5/8 in.)

Of deep shape with rounded sides and slightly inverted lip, this bowl is covered with a thick blue glaze that thins at the lip rim and stops just at the foot rim. The base is fully glazed, however, the foot rim is unglazed and has burned brown in firing.

A very similar bowl, formerly in the collection of Oscar Raphael is now in the British Museum.[1] Related bowls are in the Kwan[2] and Meiyintang[3] collections, and another Jun bowl, of similar shape, but with violet spots on the exterior, is in the Eli Lilly collection.[4]

 1. Illustrated by Honey, *The Ceramic Art of China*, pl. 47a, and again in Kōyama and Pope, eds., *Oriental Ceramics, The World's Great Collections*, vol. 5, *The British Museum* (Tokyo, 1981), monochrome pl. 102.
 2. Illustrated in Hong Kong Museum of Art, *Song Ceramics from the Kwan Collection*, pp. 112-113, no. 38.
 3. Krahl, *Chinese Ceramics from the Meiyintang Collection*, p. 221, no. 386.
 4. See Yutaka Mino and James Robinson, *Beauty and Tranquility: The Eli Lilly Collection of Chinese Art* (Indianapolis, 1983), cover and pl. 83.

18.
JUNYAO WATER POT
Jin Dynasty, late 12th – 13th century
Jun kilns, Henan province
H. 10.2 cm (4 in.)

Of lotus bud form with rounded sides curving inward to the mouth, this vessel is covered with a thick, light blue glaze that has drained from the lip rim leaving it unglazed and burned a brownish color. The pot is embellished on one side by a horizontal cloud of dark bluish purple with touches of magenta. The glaze falls short of the foot rim leaving the foot and base unglazed and revealing the dense, buff, stoneware body.

The decoration of this water pot—the purplish horizontal "cloud" band—is caused by copper filings sprinkled into the glaze prior to firing. Early in the twelfth century, Jun potters discovered that the addition of copper to the glaze would cause bright purple suffusions to form in the fired piece. Further into the Jin period, these suffusions became a more prominent feature of Jun ware decoration.

Jun water containers of this elegant form are well represented in public and private collections. A number of them have their original covers, including those in the Chang Foundation,[1] the Metropolitan Museum of Art,[2] the City Art Gallery, Bristol,[3] and the Palace Museum, Beijing.[4] Similar water pots, without their covers, are in the Museum of Decorative Art, Copenhagen,[5] the Baur Collection,[6] the Meiyintang collection,[7] and the former collection of Dr. Yip Lee.[8]

This lotus bud form is also found in northern black wares of the period, as evidenced by number 36 in this catalogue.

1. Illustrated in Chang Foundation, *Selected Chinese Ceramics from Han to Qing Dynasties* (Taipei, 1990), p. 98, no. 3.
2. See Valenstein, *Handbook of Chinese Ceramics*, p. 87, no. 79.
3. Illustrated in *Mostra d'Arte Cinese* (Venice, 1954), p. 137, no. 483.
4. Palace Museum, Beijing. *The Complete Treasures of the Palace Museum*, vol. 32: *Porcelain of the Song Dynasty* (Hong Kong, 1996), p. 242, no. 218.
5. Andre Leth, *Catalogue of Selected Objects of Chinese Art in the Museum of Decorative Art* (Copenhagen, 1959), no. 86.
6. See Ayers, *The Baur Collection*, pl. A 30.
7. Krahl, *Chinese Ceramics from the Meiyintang Collection*, p. 222, nos. 392-393.
8. Illustrated in Christie's, *An Exhibition of Important Chinese Ceramics from the Robert Chang Collection* (London, 1993), p. 22, no. 3. Another water pot, glazed in pale blue, is illustrated in the same catalogue, p. 24, no. 4.

19.

CIZHOU PILLOW WITH "FISH-ROE" GROUND

Northern Song Dynasty, early to mid-11th century
Cizhou kilns, Dengfeng xian or Mixian kilns, Henan
W.: 19 cm (7 1/2 in.)

Exhibited: Wood, *Art of China and Japan*, no. 29.
Published: Yutaka Mino, "Tz'u-chou-Type Ware Decorated with Incised Patterns on a Stamped 'Fish-Roe Ground,' " *Archives of Asian Art*, XXXII, 1979, p. 64, pl. 17.

Provenance: John Henry Levy

This bean-shaped pillow is covered with a white slip and transparent glaze. The slightly concave top is incised through the slip with a design of two blossoms surrounded by leaves on a ground comprised of small circles, a pattern commonly known as "fish-roe." The sides are decorated with an incised band of freely drawn, feathery scrolls. The flat base in unglazed, showing the reddish-brown stoneware body.

Cizhou wares were produced by kilns in northern China during the Northern Song, Jin and later periods. The primary kiln centers for this broad family of wares has been identified as Cixian (known in the Northern Song and Jin as Cizhou, hence the name), in the vicinity of northern Henan and southern Hebei provinces. However, kilns in many other provinces also produced this type of stoneware, characterized by the monochrome, low-fired lead glazes used over boldly conceived painted, incised or sgraffito decoration. Sgraffito designs, wherein a design is created by cutting through a layer of thick white slip to reveal the underlying body, are commonly seen on Cizhou pillows.

The eleventh-century date of this pillow has been assigned on the basis of a very similar bean-shaped pillow with an incised design of three blossoms on a fish-roe ground recovered from the Dengfeng xian kilns in Henan.[1] The incised flowers on the top of the Dengfeng pillow have an exact counterpart in a fragment recovered from the Mixian kilns, another Cizhou site in Henan,[2] suggesting these sites as the most likely sources of manufacture for this pillow and others of its type. Related floral motifs can be seen in a similarly-shaped pillow in the Royal Ontario Museum collection.[3] Two other bean-shaped pillows featuring related, but non-floral motifs, are in the British Museum and the Indianapolis Museum of Art.[4]

 1. Illustrated in Mainichi Shimbusa, *China's Beauty of 2000 Years*, no. 76. The same pillow is also illustrated by Mino, "Tz'u-chou-type Ware," p. 64, pl. 14.
 2. *Wenwu* 3 (1964): 50, fig. 8:4. Wirgin, *Sung Ceramic Designs*, p. 92, n. 1 comments on the relationship between the pillow and sherd and remarks that the two kilns seem to have produced almost identical wares.
 3. Mino, "Tz'u-chou type Ware," p. 64, pl. 15, and again, in Yutaka Mino, *Freedom of Clay and Brush Through Seven Centuries in Northern China: Tz'u-chou Type Wares, 960-1600 A.D.* (Indianapolis, 1980), pl. 20.
 4. Both pillows are illustrated in Mino, *Freedom*, pl. 16 and 19 and Wirgin, *Sung Ceramic Designs*, pl. 42a, c, d and e. Wirgin discusses this pillow, along with the ROM and Dengfeng pillows in the text on p. 92, under Type Tc5. Wirgin and Mino's earlier publication, "Tz'u-chou Type Wares" refer to the Indianapolis pillow as being in the Wellesley College Art Museum.

69

20.

CIZHOU VASE WITH FLARED NECK AND ROLLED LIP
Northern Song Dynasty, 11th-12th century
Cizhou kilns
H. 20.5 cm (8 in.)

Exhibited/Published: Wood, *Art of China and Japan*, no. 30.

Provenance: Mrs. Evelyn Thudium, Arkansas
 Henry Stern, New Orleans

Standing on a high, splayed foot, this vase has an ovoid body which gives rise to a tall, cylindrical neck that flares outward to a rolled lip. The vase is covered with a white slip and clear glaze, except for the foot rim and base, which are unglazed, showing the dense, light gray stoneware body.

This trumpet-necked vase with rolled lip is closely associated with a quantity of similarly potted and glazed stonewares recovered from the dwelling site of Zhuluxian, in Hebei province, which was destroyed by floods in 1108. Vases of this Zhuluxian-type are also found in Western collections, including that of Mrs. C. G. Seligman.[1]

This shape is well known in Cizhou vases with sgraffito decoration, usually in black slip over white slip. Recent archaeological finds at the Cizhou kiln site of Guantai have also revealed a similar vase, decorated by sgraffito, in a strata dating from the mid-twelfth century.[2] Other vases featuring this type of decoration include vases in the Bristol Museum and Art Gallery[3] and the Victoria and Albert Museum.[4] This distinctive shape of vase also has been found in northern black wares of Cizhou type.[5]

1. Illustrated in Oriental Ceramic Society, *The Arts of the Sung*, pl. 43, no. 112, and again in Ayers, *The Seligman Collection*, pl. XXIX, D72.
2. Beijing daxue kaogu xuexi, et al., *Guantai Cizhou Yaozhi* (Beijing, 1997), color pl. IX:2 and p. 123, fig. 52:1. Two other vases of this type are illustrated by Mino in *Freedom*, p. 108, figs. 106-7.
3. See the Oriental Ceramic Society, *Iron in the Fire: The Chinese Potter's Exploration of Iron Oxide Glazes* (London, 1988), no. 32, illustrated in color on p. 21 and in black and white on p. 47.
4. Kōyama and Pope, eds., *Oriental Ceramics, World's Great Collections*, vol. 6, *The Victoria and Albert Museum, London*, monochrome pl. 113.
5. A black-glazed, ribbed vase of this shape is illustrated in Hasebe, *Sekai Tōji Zenshū*, p. 244, no. 247.

21.
SMALL CIZHOU BOWL WITH DOTTED FLORAL DECORATION
Late Northern Song Dynasty, 11th - early 12th century
Cizhou kilns, Guantai, Cixian, Hebei province
D. 11.5 cm (4 7/16 in.)

Exhibited/Published: Wood, *Art of China and Japan*, no. 33.

Provenance: Emmanuel Gran
 Warren E. Cox

With rounded sides and a collared, slanting lip, this bowl is covered with white slip and transparent glaze falling well short of the foot rim. The exterior is decorated with an abstract floral pattern of five circles, each comprised of six dots of olive-brown glaze. The dense light gray stoneware body is exposed on the unglazed lower portions of the exterior, the foot rim and base.

The large number of Cizhou vessels bearing dotted rosettes attests to the popularity of this method of decoration, particularly among wares associated with the major kiln site of Guantai in southern Hebei province.[1] From the latter half of the tenth to mid-twelfth centuries, dotted motifs are among the most common forms of decoration at Guantai, peaking in popularity in the mid-eleventh to early twelfth centuries. A number of bowls very similar in construction and decoration to the present bowl have been recovered from Guantai, all dating to the first half of the twelfth century.[2] Another small bowl decorated with dotted flowers has been recovered from Zhuluxian, the Song dwelling site destroyed by floods in 1108.[3] A bowl closely related to the present example is in collection of the Ashmolean Museum.[4]

 1. See Beijing daxue, *Guantai*, color pl. XX:2.
 2. See, for example, *Wenwu* 4 (1990): 10, pl. 19, and in line drawing p. 9, fig. 18:18 and *Wenwu* 8 (1964): 41, fig. 8:3. Others are illustrated in Beijing daxue, *Guantai*, pl. XIII:2, and p. 83, fig. 34:6, 7 and 11; and Idemitsu Museum, *Unearthed Treasures*, pl. 172.
 3. Illustrated in Mino, *Freedom*, p. 114, figure 117.
 4. Tregear, *Song Ceramics*, p. 13, pl. 4.

22.

LARGE CIZHOU BOWL WITH SKETCHY FLORAL DESIGN

Late Northern Song Dynasty
Cizhou kilns, possibly Haobiji, Henan
D. 22.8 cm (9 in.)
Exhibited/Published: Wood, *Art of China and Japan*, no. 34.

Provenance: Mathias Komer, New York
Thomas Barlow Walker, Minneapolis

This bowl stands on a relatively small foot, from which rise broad, rounded sides that end in a straight, unadorned lip. The glaze, comprised of a white slip covered by a thin clear glaze, falls short of the foot. The interior of the bowl is decorated with a freely executed design of a peony blossom surrounded by foliage, carved and combed through the slip to the underlying body. There are five discrete spur marks in the interior. The dense, pale gray stoneware body is exposed at the unglazed foot and base.

A virtually identical bowl has been discovered in the late Northern Song stratum at the Cizhou kiln site of Haobiji in Henan.[1] Another, very similar bowl from the same kiln site features an incised lotus design on a combed background.[2] A bowl of similar type, size, shape and docoration, found within a Liao Dynasty context, is now in the Liaoning Provincial Museum.[3]

The decoration on this bowl is a much looser rendering of the peony design seen in numbers 11 and 46 in this catalogue.

1. *Wenwu* 8 (1964):7, pl. 2:5.
2. University of Hong Kong Art Gallery, *Ceramic Finds from Henan* (Hong Kong, 1997), p. 92, pl. 63.
3. Illustrated in Liaoning Provincial Museum, *Liaoci Xuanji* (Beijing, 1961), no. 95.

23.
SMALL CIZHOU BOWL WITH COMBED DECORATION
Jin Dynasty, mid-twelfth to early 13th century
Cizhou kilns at Guantai, Cixian, Hebei province
D. 10.2 cm (4 in.)

Thinly potted and almost hemispherical in shape, this bowl is covered with white slip and a clear glaze and is decorated on the interior with combed flourishes in an abstract design within an incised circle. There are five tiny spur marks on the interior. The base is partly glazed, but the foot rim is unglazed, showing the pale gray stoneware body.

This type of combed decoration is found on a number of similarly glazed bowls excavated at the Guantai kiln site. In some, the design is nonrepresentational, as in the present example.[1] In others, the combing technique sketchily renders a blossom and foliage.[2] Both types date from the mid- to late Jin Dynasty (1149-1219).[3] The collection of the Arthur M. Sackler Museum of Art and Archaeology, Beijing, also has another bowl of this type.[4]

 1. Beijing daxue, *Guantai*, color pl. 5:2; p. 63, fig. 26:4; p. 68, fig. 28:1, 7; and p. 81, fig. 33:1.
 2. Ibid., pl. XII:1; p. 70, pl. 29:10.
 3. Ibid., p. 600.
 4. Idemitsu Museum, *Unearthed Treasures*, pl. 179.

24.
CIZHOU BOTTLE OF MEIPING SHAPE
Yuan Dynasty, early 14th century
Cizhou kilns
H. 24.8 cm (9 3/4 in.)

Published/Exhibited: Wood, *Art of China and Japan*, no. 32, p. 25.

Provenance: Warren E. Cox

Ovoid in form, with full rounded sides tapering to a slightly flared foot, this bottle of *meiping* shape has a small mouth, with a thick, rounded lip. The vessel is covered with a creamy white slip and transparent glaze falling short of the foot. The exposed body, visible just above the foot, on the thickly potted foot rim and on the base, is of a dense, finely speckled, buff-colored stoneware.

Bottles of this distinctive shape, with small mouths, wide shoulders and constricted waists, are commonly called *meiping*, or plum vases, connoting a decorative, rather than utilitarian purpose for the vessel. During the Song and Yuan, however, bottles of this shape most often served as storage containers for liquids such as wine.[1]

A number of similarly shaped and glazed Cizhou Yuan-period *meiping* bear the inscription *nei fu* ("palace repository") on their shoulders. One such vessel, with the inscription in underglaze iron brown, is in the collection of the Tokyo National Museum,[2] and another was found in a Yuan storage cellar at Liangxiangzhen in Beijing.[3] A variation on this theme is the dark-brown glazed *meiping* of this same shape with the characters *nei fu* carved through the glaze to the white body beneath.[4]

1. See Mowry, *Hare's Fur*, p. 253, for a discussion of the term, the shape and its history.
2. Illustrated in Tokyo National Museum, *Illustrated Catalogue of the Tokyo National Museum* (Tokyo, 1965), p. 76, no. 312. The same vase is illustrated in Mino, *Freedom*, pl. 73.
3. *Kaogu* 6 (1972): 33:4. The same *meiping* is illustrated by Mino, *Freedom*, p. 170, fig. 189.
4. Illustrated in Museum für Ostasiatische Kunst, *Form und Farbe, Chinesische Bronzen und Frühkeramik, Sammlung H.W. Siegel* (Berlin, 1973), no. 90.

25.
BLACK-GLAZED RIBBED ZHADOU WITH FOLIATE RIM
Northern Song Dynasty, 11th century
Cizhou kilns
H. 10.2 cm (4 in.)

Exhibited/Published: Mowry, *Hare's Fur*, no. 60, pp. 173-74.

 This vessel, whose form has been discussed in an earlier entry,[1] is comprised of a compressed bowl with an incurved lip surmounted by a tall, cylindrical neck and foliate rim. An indented ring delineates the bowl from the neck, which rises vertically to the lip and has six alternating vertical and flaring foliations. The foliations were produced by the bending over of the lip in six evenly spaced segments. The vessel, glazed in dark brown, is decorated in its lower portion with eight pairs of vertical white ribs that extend from the base of the neck to the foot. Six similarly formed slip-trailed vertical white ribs appear on the interior of the neck, one descending from the center of each vertical foliation. An area at the bottom of the interior, as well as the foot and the base, are unglazed, showing the dense, buff-colored stoneware.

 Dark-glazed ceramics have a long history in China, originating in the third century and reaching an aesthetic peak in the Song, Jin and Yuan periods.[2] The Cizhou family of kilns, which produced the white wares seen in the preceding entries, also manufactured dark-glazed wares beginning in the tenth century. The Song appreciation of dark-glazed ceramics parallels the esteem for dark lacquerwares of the period.[3] Like lacquers, dark-glazed vessels are usually simple and elegant in form, and the russet, brown, and a very dark brown (almost black) glazes that cover these wares emphasize these restrained shapes. Any decoration, such as the ribbing seen here, further accentuates the form of the vessel, creating movement both horizontally and vertically.

 The *zhadou* is a relatively unusual shape, and it is uncommon to find it in black wares. While it is tempting to connect this black-glazed *zhadou* to the Yaozhou *zhadou* also in the Barron collection, no dark-glazed examples of this type have been unearthed at the Yaozhou kilns.[4]

 1. See cat. 10.
 2. Mowry, *Hare's Fur*, p. 24.
 3. The most complete discussion of dark-glazed ceramics from the fifth to the fifteenth centuries is Mowry, *Hare's Fur*.
 4. Ibid., p. 174.

26.
CONICAL BOWL WITH RUSSET GLAZE
Northern Song - Jin Dynasty
Cizhou kilns
D. 15.3 cm (6 in.)

Published/Exhibited: Wood, *Art of China and Japan*, p. 26.

Provenance: Frank Caro

The walls of this thinly potted shallow conical bowl rise from a small foot, and flare outward, everting slightly at the lip rim. Fully covered with a russet-color glaze, this bowl is undecorated except for triple incised lines encircling the exterior just below the lip rim. At the foot, only the foot rim is left unglazed, exposing the pale, buff, stoneware body.

Conical bowls with straight flaring sides and a small foot appeared during the late Tang, and by the tenth century had become a standard shape. By the next century, their forms included the V-shaped profile and tiny well-defined floor seen here. Conical bowls were intended primarily for the drinking of tea. During the Song and Jin, dark-glazed tea bowls became increasingly popular as the red tea consumed during the Tang was supplanted by a white tea that looked more appealing in a vessel of contrasting color.

Russet glazes are, in fact, a dark-brown glaze covered by a paper-thin layer, or "skin." The russet-colored skin appears when the glaze is saturated with more iron than it can absorb, and during the firing the excess iron segregates itself from the primary glaze.[1]

Excavations at the Cizhou kilns of Guantai reveal that bowls of similar size and glazing were produced during the mid-eleventh to twelfth centuries.[2] Similar bowls in Western collections include an unadorned russet-glazed bowl in the Museum of Fine Arts, Boston[3] and two bowls of this shape and of Cizhou type, but with russet-mottled black glazes in the Arthur M. Sackler Museum, Harvard University.[4] The same shape also appears in russet-glazed Ding ware, as is evidenced by a bowl in the collection of the Seattle Art Museum,[5] and another in the Sackler Museum at Harvard University.[6]

 1. See Mowry, *Hare's Fur*, p. 106 and Oriental Ceramic Society, *Iron in the Fire*, p. 10.
 2. Beijing daxue, *Guantai*, p. 268, fig. 114:12-13.
 3. Tseng Hsien-ch'i and Robert Paul Dart, *The Charles B. Hoyt Collection in the Museum of Fine Arts, Boston*, vol. 2, *Chinese Art of the Liao, Sung and Yuan Dynasties* (Boston, 1972), no. 122.
 4. Illustrated in Mowry, *Hare's Fur*, p. 140, no. 37a,b.
 5. See Seattle Art Museum, *Asiatic Art in the Seattle Art Museum* (Seattle, 1973), no. 119, color pl. 56.
 6. This is illustrated in Mowry, *Hare's Fur*, no. 15, along with another Ding russet bowl of similar shape, no. 14.

83

28.
RUSSET-GLAZED RIBBED JAR WITH LOOP HANDLES
Northern Song - Jin Dynasty
Cizhou kilns, Henan or Hebei province
H. 14 cm (5 1/2 in.)

 The slightly rounded sides of this jar emanate from a short foot, and rise upward, turning gently inward at the shoulder. A short, straight neck rises from the shoulder. Two loop handles, comprised of three strands of clay, extend from the neck to the shoulder, trailing a short way down the walls of the jar. The body of the vessel is decorated with vertical slip-trailed ribs arranged in evenly spaced groups of three, extending from the shoulder to just above the foot. The jar is covered with a thick russet glaze over the upper portion of the interior and most of the exterior, falling short of the foot onto a thinner caramel-colored underglaze that covers the remainder of the vessel, inside and out. Due to its thickness, the glaze has not drained away from the ribs as it usually does in vessels decorated in this manner. The foot rim and base are unglazed, showing the very pale, buff stoneware body.

 A black-glazed, two-handled jar of similar shape and with vertical ribs arranged in groups of four is in the Hirota Collection, Tokyo National Museum.[1]

 1. Illustrated in Tokyo National Museum, *The Hirota Collection, Tokyo National Museum* (Tokyo, 1973), no. 87, and again in Tokyo National Museum, *Illustrated Catalogues of the Tokyo National Museum, Chinese Ceramics*, vol. I (Tokyo, 1988), p. 156, no. 625.

29.
RIBBED BLACK-GLAZED GLOBULAR JAR
Northern Song - Jin Dynasty
Cizhou kilns, Henan or Hebei province
H. 11.7 cm (4 5/8 in.)

Exhibited/Published: Seto, *Ceramics: The Chinese Legacy*, p. 16, no. 12.

This small globular jar features a low square-cut foot from which rise rounded walls, which turn inward at the shoulder and give way to a short, straight neck. A glossy black glaze covers the exterior of the jar falling quite short of the foot. The interior is covered by a thin, nearly colorless transparent glaze. Evenly spaced vertical ribs of trailed white slip encircle the exterior, extending from the base of the neck to the lower border of the black glaze. The lip rim, lower exterior, foot and base are unglazed, showing the dense, very pale gray stoneware body.

Ribbed vessels of various sizes and shapes were made at a number of kilns in Shandong, Henan and Hebei provinces during the Northern Song and Jin. While no comparable examples have been discovered yet at the excavated kiln sites, the placement and application of the trailed slip lines and the straight-cut foot seem to indicate that this jar originated in Hebei or Henan province.[1]

A number of similar jars are in Asian and Western collections, including examples in the Buffalo Museum of Science,[2] the Seligman Collection at the British Museum,[3] and another in a Japanese collection.[4]

1. See Mowry, *Hare's Fur*, p. 177, for a full discussion of the differences among ribbed black wares from Shandong, Henan and Hebei. Ribbing techniques and proposed antecedents are explicated on p. 176.
2. Illustrated by Hochstadter, "Ceramics of the Five Dynasties and Song Periods," no. 76.
3. The jar is illustrated in both Ayers, *The Seligman Collection*, pl. XLVIII, D132; and Kōyama and Pope, eds., *Oriental Ceramics, The World's Great Collections*, vol. 5, *The British Museum, London*, monochrome pl. 122.
4. Illustrated in Mayuyama and Co., Ltd., *Mayuyama: Seventy Years*, p. 191, no. 567.

30.

LARGE WIDE-MOUTHED JAR WITH VERTICAL RIBS AND TWO HANDLES

Northern Song to Jin Dynasty, 12th century
Cizhou-type kilns, Henan or Hebei province
H. 20.6 cm (8 1/8 in.)

This jar has an ovoid body and a wide collar-like neck which ends in a rounded lip rim. A very dark brown, almost black, glaze covers the uppermost interior and most of the exterior of the vessel. This glaze ends in an irregular line above the foot, where it meets a caramel-colored underglaze that coats the remainder of the exterior, the base and the interior. Vertical slip-trailed ribs in close parallel encircle the body, appearing pale tan against the black glaze. The ribs begin at the base of the neck and terminate just above the juncture of the dark and caramel-colored glazes. Two broad, ribbed, tapering strap handles extend from just below the lip of the vessel to the shoulder. The broad foot rim is unglazed showing the dense gray stoneware body.

Similar dark-glazed, white-ribbed, wide-mouthed jars with collared necks have been found both in tombs and, as sherds, at a number of kiln sites in Shandong, Hebei and Henan provinces.[1] Given the widespread nature of production, most of which dates to the twelfth and thirteenth centuries, it is difficult to ascribe this jar to a particular kiln site. Certain characteristics, however, including the rolled lip, striated handles, tall, tapered, collared neck and use of the caramel-colored glaze on the lower portions and inside of the vessel indicate its general area of production as Henan or Hebei,[2] with the jar closely resembling material from the kilns at Haobiji in Henan province.[3] Whichever kiln is responsible, the striking similarites in potting, technique of glazing and cut of the foot of this jar and the black-glazed globular jar with rope-twist handles also in this collection (cat. 31), leave little doubt that the two have a common source of manufacture.

A number of related jars are in public and private collections. In Japan, a virtually identical jar is in the Hakone Art Museum,[4] and another, formerly in the Malcolm Collection, is in the Matsuoka Museum.[5] The Szekeres collection has a larger, but otherwise very similar jar,[6] as does the Nelson-Atkins Museum,[7] the Chang Foundation[8] and the Freer Gallery of Art.[9]

 1. See, for example, Beijing daxue, *Guantai*, pl. LIV. Mowry, *Hare's Fur*, p. 176 enumerates the kiln sites, tombs and other sites that have yielded similarly decorated material. See particularly p. 178, fig. 7-14.
 2. Ibid., pp. 176-7 for Mowry's detailed discussion of the differences amongst vessels made in Shandong, Hebei and Henan.
 3. This opinion is voiced by Mowry, p. 177. A closely related jar, from Haobiji is illustrated in Zhao Qingyun, *Henan Taoci Shi* (Beijing, 1993), pl. 27, no. 109. See also, Mino, "Recent Finds of Chinese Song and Yuan Ceramics," in George Kuwayama, ed., *Perspectives on the Art and Ceramics of China* (Los Angeles, 1992), p. 39, n. 67b.
 4. This jar is illustrated in Mayuyama and Co., Ltd., *Mayuyama: Seventy Years*, p. 192, no. 569.
 5. Wirgin, *Sung Ceramics*, pl. 53k.
 6. Illustrated by Mowry, *Hare's Fur*, p. 175, no. 61.
 7. Illustrated in Roger Ward and Patricia J. Fidler, *The Nelson-Atkins Museum of Art: A Handbook of the Collection* (New York, 1993), p. 296.
 8. Chang Foundation, *Ten Dynasties of Chinese Ceramics from the Chang Foundation*, no. 26.
 9. Illustrated in the Freer Gallery of Art, *Masterpieces of Chinese and Japanese Art: Freer Gallery of Art Handbook* (Washington, D.C., 1976), p. 67.

31.

LARGE BLACK-GLAZED GLOBULAR JAR WITH RUSSET DECORATION AND ROPE-TWIST HANDLES

Northern Song - Jin Dynasty, 12th century
Cizhou kilns, Henan or Hebei province
H. 19 cm (7 1/2 in.)

Provenance: Mathias Komor, New York
Phillip Hofer, Boston

Of almost spherical form, this jar has a short, straight neck and a pair of rope-twist handles set high on the shoulders. The exterior is covered with a glossy black glaze with bluish undertones and is decorated with twelve groups of small russet splashes arranged to resemble five-petalled blossoms. A number of the splashes have run in the firing creating an abstract effect. The black glaze falls short of the foot in an undulating line onto a thin caramel-colored underglaze that coats the remainder of the exterior, the base and interior. Both the lip rim and the foot rim are unglazed showing the pale buff stoneware body.

The in-glaze method of decorating dark-glazed wares with russet splashes appeared at the northern Cizhou-type kilns in the eleventh century. The russet rosettes that decorate the present jar were touched onto the surface of the dark glaze with iron oxide. The resulting russet color is obtained in the same fashion for these splotches as for those objects completely covered in russet, seen in preceding entries (cat. 26-28).

Similarities in potting, glazing technique, and construction of the foot between this jar and another in the Scheinman Collection[1] have led experts to believe the two are from the same kiln. Exactly the same characteristics are shared by the black-glazed ribbed jar, also in this collection (cat. 30). There can be little doubt that these jars all originate from the same kiln site.

1. Mowry, *Hare's Fur*, no. 40, pp. 145-6. Mowry also discusses the Barron jar in this entry.

32.
JAR WITH RUSSET-SPLASHED BLACK GLAZE AND LOOP HANDLES
Northern Song - Jin Dynasty
Cizhou kilns, probably Guantai, Cixian, Hebei
H. 13 cm (5 1/8 in.)

Published/Exhibited: Wood, *Art of China and Japan*, no. 37, p. 26.

Provenance: Mathias Komer

The rounded body of this jar gives way to a tall, wide, cylindrical neck that tapers slightly inward before culminating in an everted lip rim. Two double-stranded loop handles are disposed on opposite sides of the vessel, luted at the juncture of neck and body and ending at the fullest circumference of the lower portion. A glossy black glaze with bright russet-colored splashes covers three-quarters of the jar, falling well short of the foot. In addition to the interior and lower portion of the exterior, the lip rim, foot rim, and base are unglazed, revealing the gray stoneware body.

This general type of two-handled jar, with rounded bodies and cylindrical necks, was produced at the Cizhou kiln of Guantai from the early Northern Song through the fourteenth century.[1] Variations in the profile and proportion of each element of these jars are evident for each time period. A vessel of the same shape and nearly identical proportions to the Barron jar has been recovered from Guantai, in a stratum dating from the first half of the twelfth century.[2] Reinforcing the attribution the the twelfth century is the presence of a similar jar, said to have been found at Qinghexian.[3] Other, very similar examples are in private collections in Japan[4] and Germany.[5]

1. See Beijing daxue, *Guantai*, p. 220, fig. 94:1-3, 5, 6, 9.
2. Ibid., b/w plate LI, no. 6 and p. 220, fig. 94:9.
3. Illustrated by Nils Palmgren, *Sung Sherds* (Stockholm, 1963), p. 230, fig. 12.
4. In Fujio Kōyama, *Tōji Taikei*, vol. 38; *Temmoku* (Tokyo, 1974), no. 64.
5. See Museum für Kunst und Gewerbe, *Tausend Jahre Chinesische Keramik aus Privatbesitz* (Hamburg, 1974), p. 62, no. 55.

33.
SMALL LOBED BOWL WITH RUSSET-STREAKED BLACK GLAZE
Northern Song - Jin Dynasty
Cizhou kilns
D. 10.5 cm (4 1/8 in.)

This shallow bowl has rounded sides and a slightly incurved rim. Vertical indentations divide the bowl into eight lobes. Covered in a black glaze both inside and out, the interior of the bowl is boldly streaked and swirled with bright russet. The lower portion of the exterior and the flat base are unglazed, showing the compact, buff-colored stoneware.

The segmentation of ceramic vessels began in the Tang, becoming widespread in the tenth and eleventh centuries. As with foliated lip rims, the segmentation of jars into lobes traces its origins to Tang silver prototypes, where the divisions subtly suggest an open flower or a ripe melon. Sourced in nature, this ceramic lobed bowl is transformed by the bold abstract designs which grace its interior.

A deeper bowl from the deMenasce collection is similarly lobed, glazed in black with russet splashes and has a flat base.[1]

1. Illustrated in Oriental Ceramic Society, *The Arts of the Sung Dynasty*, pl. 31, no. 71.

34.

SMALL BLACK-GLAZED CONICAL BOWL WITH RUSSET MOTTLES
Northern Song - Jin Dynasty
Cizhou kilns, probably Hebei province
D. 12.2 cm (4 3/4 in.)

Provenance: Captain E.G. Spencer-Churchill, M.C., Northwick Park Collection, England

Conical in shape, this bowl has slightly rounded walls which terminate in an everted lip rim. The interior is covered with a glossy black glaze embellished with russet spots and splashes. The glaze on the upper portion of the exterior, nearest the lip, is similarly mottled with russet. As the glaze travels farther down the exterior wall the predominant color becomes russet. The glaze ends well above the foot. The unglazed portions of the vessel, including the lower exterior, the small, shallow foot, and base reveal a buff stoneware body.

Similar bowls have been excavated at the Cizhou kiln site of Guantai, in a stratum attributed to the mid- to late Northern Song.[1] A number of closely related bowls are in the Arthur M. Sackler Museum at Harvard University,[2] the Scheinman Collection,[3] the Meiyintang Collection,[4] the Barlow Collection,[5] and the collections of Robert Ferris[6] and H. W. Seigel.[7]

 1. These bowls have been illustrated in *Wenwu* 4 (1990): 7:14; Beijing daxue, *Guantai*, color pl. XXIX:3 b/w pl. LXI:1 and Idemitsu Museum, *Unearthed Treasures*, no. 169.
 2. Illustrated in Mowry, *Hare's Fur*, p. 143, no. 33a.
 3. Ibid, no. 33b.
 4. Illustrated by Krahl, *Chinese Ceramics from the Meiyintang Collection*, p. 258, no. 470.
 5. This somewhat larger bowl is illustrated in Oriental Ceramic Society, *The Arts of the Sung Dynasty*, pl. 30, no. 70, and again in Michael Sullivan, *Chinese Ceramics, Bronzes and Jades in the Barlow Collection* (London, 1963), pl. 53c.
 6. Illustrated in J.J. Lally and Co., *Brush and Clay* (New York, 1997), p. 76, no. 17.
 7. Seen in Tregear, *Song Ceramics*, p. 188, nos. 258-59.

35.

SMALL BLACK-GLAZED CONICAL BOWL DAPPLED IN RUSSET
Northern Song - Jin Dynasty
Cizhou kilns, probably Hebei province
D. 12.2 cm (4 3/4 in.)

Published/Exhibited: Seto, *Ceramics: The Chinese Legacy*, p. 16, no. 13; Wood, *The Art of China and Japan*, no. 42.

The gently rounded sides of this small conical bowl culminate in a slightly everted lip rim. The interior is covered with a black glaze extensively dappled with clouds of tiny russet spots. The glaze on the exterior is largely russet in color and falls well short of the foot. The lower portion of the exterior, the small, shallow foot, and the base are unglazed, showing the buff-colored stoneware body.

This bowl is virtually identical in size, shape, potting and in body to the preceding bowl (cat. 34). As has been discussed, black-glazed bowls with this pattern of tiny, russet markings have been recovered from the Guantai kiln site in Cixian, Hebei province,[1] including a seemingly identical bowl, dating from the late eleventh to early twelfth century.[2]

1. See Idemitsu Museum, *Unearthed Treasures*, pl. no. 173d.
2. Beijing daxue, *Guantai*, color pl. XXIX:1.

36.
LOTUS-BUD WATER POT WITH TEA-DUST GLAZE
Northern Song - Jin Dynasty
Cizhou kilns
H. 10.4 cm (4 1/8 in.)

Exhibited: Wood, *The Art of China and Japan*, no. 44a.

Provenance: Warren E. Cox

In the form of a lotus bud, this water pot has full, rounded sides, curving inward toward the mouth. It is covered with a finely speckled dark olive-brown glaze of tea-dust type, which falls short of the foot. The lower portion of the exterior, the foot rim and the base are dressed with a thin, purplish, brown slip.

The semi-lustrous olive-brown glaze seen on this vessel is most commonly referred to as "tea-dust." First appearing in the seventh century, these glazes became particularly popular during the Song, Jin and Yuan periods. Created through the slight underfiring of the wares, tea-dust glazes are a variant of a dark-brown glaze. Almost all black wares pass through a tea-dust phase in firing; it is both the kiln temperature and duration of firing that determines whether the resulting glaze is tea-dust or black.[1]

The lotus-bud form is seen in a number of black-glazed wares in collections outside of China, including tea-dust glazed examples in the former collection of C. T. Loo,[2] and in the Meiyintang collection.[3] An oil-spot glazed example is in the collection of Brian S. McElney,[4] and another pot of this same shape, covered with a brownish-black glaze, is in the collection of Carl Kempe.[5] The lotus-bud form is also found in Jun wares.[6]

1. See Mowry, *Hare's Fur*, p. 90, for more on tea-dust glazes.
2. llustrated in, C. T. Loo, *Exhibition of Chinese Arts* (New York, 1941), no. 64. According to Warren Cox, this is the same pot as the Barron example under discussion.
3. See Krahl, *Chinese Ceramics from the Meiyintang Collection*, p. 245, no. 443.
4. This pot is illustrated both in Hong Kong Museum of Art, *Chinese Antiquities from the Brian S. McElney Collection* (Hong Kong, 1987), p. 105, no. 64; and Brian S. McElney, *Inaugural Exhibition*, vol. 1, *Chinese Ceramics, The Museum of East Asian Art* (Bath, 1993), p. 156, no. 110.
5. Illustrated by Bo Gyllensvärd, *Chinese Ceramics in the Carl Kempe Collection* (Stockholm, 1964), p. 94, no. 266.
6. Evidenced by cat. 18 above.

37.
SMALL BLACK-GLAZED JAR WITH FIVE LARGE RUSSET SPOTS
Northern Song - Jin Dynasty, mid to late 12th century
Cizhou kilns
D. 11.4 cm (4 1/2 in)

Rising from a small circular foot, the walls of this jar arc in an elliptical fashion, culminating in a straight lip rim. Five large, evenly spaced oval russet spots embellish the russet-streaked black glaze that covers the interior and exterior of the vessel. The unglazed portions of the vessel, which reveal the buff-colored stoneware body, include the lower portion of the exterior, the lip and broad foot rims, and the base.

The regularized pattern evident in the decoration of this bowl is characteristic of twelfth and thirteenth-century blackwares from the Cizhou kilns. The large size and even spacing of the russet spots reflects a taste for structured design often seen in Jin wares.

Black-glazed jars of similar shape and decoration are in the Meiyintang collection.[1]

1. See Krahl, *Chinese Ceramics from the Meiyintang Collection*, p. 254, nos. 460-1.

38.

BOWL WITH WHITE RIM AND FIVE RUSSET SPLASHES
Jin Dynasty, 12th century
Cizhou-type kilns
D. 17.7 cm (7 in.)

Exhibited/Published: Mowry, *Hare's Fur*, no. 41, pp. 147-48.

Resting upon a short straight foot, the walls of this bowl curve upward and outward, terminating in a white rim that simulates a silver band. A variegated dark brown glaze covers the remainder of the bowl, ending on the exterior in a neat line at the foot. Five large, evenly spaced, russet splashes embellish the interior of the bowl. The foot and slightly pointed base are unglazed, revealing the compact, light gray stoneware body. The exposed clay body at the foot fired a very light gray.

The white rim edging this blue black bowl had both visual impact and aesthetic resonance. The white rim provides a striking contrast to the variegated blue-black glaze splashed with russet, and also alludes to the silver bands affixed to Ding and other aristocratic wares during the Song. As in the previous entry, these evenly spaced russet elipses testify to the Jin taste for regularized patterning. This type of decoration was produced at a number of Cizhou-type kilns in the twelfth and thirteenth centuries; the kiln that manufactured this bowl cannot yet be identified.

An almost identical bowl is in the Hong Kong Museum of Art,[1] and smaller bowls of similar type are in the Barlow[2] and Scheinman collections.[3]

1. Formerly in the collection of Eugene Bernat, this bowl is illustrated in Urban Council of Hong Kong, *Emerald-like Blue Hue Rises: Chinese Ceramics Donated by the K. S. Lo Foundation* (Hong Kong, 1995), pp. 36-7, no. 10.
2. Illustrated in Sullivan, *Chinese Ceramics, Bronzes and Jades in the Barlow Collection*, no. 51c.
3. See Jason Kuo, *Born of Earth and Fire: Chinese Ceramics from the Scheinman Collection* (College Park, MD, 1992), p. 82, no. 62.

39.

BOWL WITH INCURVED RIM AND "HARE'S FUR" GLAZE, WITH THREE RUSSET SPLASHES

Jin Dynasty, 12th - early 13th century
Cizhou kilns, Henan or Hebei province
D. 14 cm (5 1/2 in.)

With rounded sides and incurved lip, this bowl is covered with a black glaze finely streaked with russet, which produces an effect known as "hare's fur." This variegated glaze is embellished, on the interior of the vessel with three, large, wedge-shaped russet splashes extending from the lip rim into the concavity of the bowl. The thick "hare's fur" glaze covers the upper portion of the exterior, ending in an uneven line, below which is a thinner, brown under-glaze, falling just short of the foot. The foot and base are unglazed, showing the rather dense, finely speckled stoneware body.

Much beloved by tea connoisseurs for their dark color against the white whipped tea popular during the Song, "hare's fur" glazed bowls were first made at the Jian kilns in Fujian, in southern China. With the fall of the north to the Jin in 1127, trade between northern and southern China diminished greatly, and Jian tea bowls were all but unattainable. Taking advantage of the market for these specialized dark-glazed wares, potters at the northern Cizhou kilns began to make their own version of "hare's fur" bowls in the twelfth and thirteenth centuries.

A somewhat larger, but otherwise nearly identical bowl is now in the collection of the New Orleans Museum of Art.[1] The close relationship in body, glazing and cut of the foot between these two bowls clearly indicate these two bowls come from the same, as yet unidentified kiln. Another similar bowl is in the Scheinman collection,[2] and a bowl of different shape, but with simlar glaze and decoration, is found in the Meiyintang collection.[3]

1. Illustrated in Sotheby Parke Bernet, *Important Chinese Ceramics, Jade Carvings and Works of Art*, New York (October 23, 1976), no. 206.
2. This bowl is illustrated and discussed in Mowry, *Hare's Fur*, p. 148, no. 42 and in Kuo, *Born of Earth and Fire*, p. 82, no 61.
3. Krahl, *Chinese Ceramics from the Meiyintang Collection*, p. 256, no. 466.

40.
SMALL-MOUTHED TEA-DUST GLAZED GLOBULAR BOTTLE DECORATED WITH BIRDS IN FLIGHT

Jin Dynasty, late 12th – early 13th century
Cizhou kilns
H. 20 cm (8 in.)

From a circular foot, the full-rounded sides of this bottle rise rapidly to a bulging shoulder, where they curve inward and culminate in a short neck with a double-ringed mouth. The bottle is covered with an olive-brown glaze of "tea-dust" type and is painted with a dark, rust-brown slip that fired to a metallic, purplish-black color. The painted design, of three stylized birds in flight, encircles the upper two thirds of the bottle. Each bird is seen from above, wings fully extended to either side, their tail feathers fanned out across the shoulder of the vessel. The base, also glazed, has a countersunk circle in the center. The foot rim is unglazed, showing the buff, stoneware body.

This ovoid bottle was a storage container, probably for wine. Similar bottles of this type in Western collections include the tea-dust glazed bottle in the collection of the Royal Ontario Museum, decorated with leaf-sprays rather than birds.[1] Another bottle of this type, painted with stylized birds in flight, but in the more usual combination of russet decoration on a black glaze is in the collection of Robert Ferris IV.[2]

1. Illustrated by Henry Trubner, *The Far Eastern Collection, Royal Ontario Museum* (Toronto, 1968), p. 58, no. 69.
2. See Mowry, *Hare's Fur*, pp. 161-63, no. 53. On p. 163, n. 4, Mowry refers to the Barron bottle under discussion.

111

41.

SMALL-MOUTHED GLOBULAR BOTTLE WITH BLACK GLAZE AND RUSSET FLORAL DECORATION

Jin-Yuan Dynasty, 13th century
Cizhou kilns
H. 21 cm (8 1/4 in.)

Exhibited/Published: Mowry, *Hare's Fur*, no. 55, pp. 165-66.

The walls of this small-mouthed bottle arc gently outward from the foot, reaching their fullest extent at the shoulder and then curving inward toward the small, flanged mouth. The bottle is glazed in thick bluish-black and is painted on either side in vigorous brushstrokes of russet slip in a design of stylized chrysanthemum and leaves. The base, which is also glazed, has a countersunk circle at its center. Only the foot rim is unglazed, revealing the buff stoneware body.

A number of similarly dark-glazed, small-mouthed vessels have survived, decorated with either floral decoration or birds in flight. The Barron bottle is one of the few decorated with an identifiable flower, rather than an abstract design. Chrysanthemums symbolize both the season of autumn and literary pursuits, as it was the favorite flower of the celebrated poet Tao Qian (Tao Yuanming, 365-427).

A similar bottle is in the collection of Simon Kwan,[1] and related examples, with differing floral decoration are in the Tianjin Municipal Museum,[2] the Museum of East Asian Art, Bath,[3] and the Palace Museum, Beijing.[4]

1. Hong Kong Museum of Art, *Song Ceramics from the Kwan Collection*, pp. 346-47, no. 155.
2. Tianjin Municipal Museum, *Porcelains from the Tianjin Municipal Museum* (Hong Kong, 1993), no. 62.
3. McElney, *Inaugural Exhibition*, vol. 1, *Chinese Ceramics*, p. 171, no. 125.
4. Palace Museum, Beijing, *The Complete Treasures*, vol. 32, pls. 212, 213.

42.
DEEP BOWL WITH BLACK GLAZE AND RUSSET STRIPES
Yuan Dynasty, 14th century
Cizhou kilns, probably Guantai, Cixian, Hebei province
D. 18.4 cm (7 1/4 in.)

Published: Palmgren, *Sung Sherds*, p. 233, fig. 16.

Provenance: J. Hellner, Sweden

The steeply rounded sides of this bowl emanate from a relatively small foot, and culminate in a slightly everted, thick lip rim. Covered by a black glaze, the interior of the bowl is decorated with two tiers of vertical russet stripes in close parallel. On the exterior, the russet-streaked and mottled glaze falls well short of the foot. A light brown underglaze extends from the lower margin of the black glaze to just above the foot rim. The buff stoneware body of the vessel is apparent in the unglazed foot rim and base.

Virtually identical bowls in shape and decoration have been recovered from the Guantai kiln site, in Cixian, Hebei province.[1] Found in the uppermost strata of the site, archaeologists have dated these wares to the fourteenth century. The decoration seen here testifies not only to the continued popularity of russet-embellished black-glazed wares into the Yuan period, but also to the simplified nature of that decoration as the northern Cizhou-type kilns enter a period of decline.

Related bowls are in the Menke[2] and Barlow[3] collections, as well as that of the Victoria and Albert Museum, London.[4]

1. Beijing daxue, *Guantai*, color pl. XXII:4.
2. Mowry, *Hare's Fur*, p. 169, no. 58.
3. Illustrated by Sullivan, *Chinese Ceramics*, no. 50a.
4. See Basil Gray, *Sung Porcelain and Stoneware* (London and Boston, 1984), p. 121, no. 97.

43.

SMALL QINGBAI WATER POT

Northern Song Dynasty, second half of the 11th century
Probably from Fanchang county, Anhui province
H. 7.6 cm (3 in.)

This ovoid water pot rests on a small, shallow, circular foot from which rounded walls rise to a broad shoulder, where they curve inward, culminating in a wide mouth. The mouth-rim is defined by a rounded, slightly raised lip. Very thinly potted and highly translucent, this water pot is undecorated except for an incised double ring just above the foot. Both interior and exterior are covered by a finely crackled pale bluish glaze which extends over the foot rim. The base is unglazed, exposing the grayish-white porcelain body.

As its name indicates, this small container was created as a water receptacle, an elegant and utilitarian accessory for the scholar's desk. Water is required for both the grinding of ink and the washing of the brush: in the preparation of ink, small amounts of water were spooned on to the inkstone, greater amounts of liquid were transferred to a separate dish for washing the brush after use. By the Northern Song period, numerous kilns created water pots of various shapes and sizes, a practice begun by potters at the Yue kilns during the Six Dynasties period. The water pot's simple form and sublimely translucent glaze are compatible with the prolonged contemplation given to these elegant scholar's objects.

The northern Jiangxi kiln complex of Jingdezhen produced the greatest volume and quality of *qingbai* wares, however, numerous kilns scattered throughout the provinces of Jiangxi, Anhui, Zhejiang, Fujian and Guangdong produced this distinctive white porcelain with transparent glaze. This water pot is most directly associated with kilns in Fanchang County, in southern Anhui province, several hundred kilometers northeast of Jingdezhen, along the Yangzi River. Excavations at the Fanchang kiln site and tomb excavations in Anhui have uncovered virtually identical water pots. Two were discovered, along with over forty other *qingbai* porcelains in a tomb datable to 1087 in Susong xian, Anhui.[1] Whether these water pots were locally produced or were from the Jingdezhen kilns has been open to debate. However the discovery of a third, remarkably similar water pot, at the Song kilns in Fanchang County seems to indicate Fanchang as the likely source of production.[2] A similar pot is in the collection of the Metropolitan Museum of Art.[3]

1. See Wang Yeyou, "Qiantan Susong xian jinian mu chutu de Bei Song yingqing cipin," *Jingdezhen Taoci* 2 (1984): 61 n. 6, fig. 1. The 1963 discovery of the tomb was reported in *Wenwu* 3 (1965): 53-54.
2. Illustrated in Hu Yueqian, "Anhui Green-glazed Wares from the Sui to Song Dynasties: Comparisons with Zhejiang Wares," in Chuimei Ho, ed., *New Light on Chinese Yue and Longquan Wares: Archaeological Ceramics Found in Eastern and Southern Asia, A.D. 800-1400* (Hong Kong, 1994), 137 pl. 2. No dimensions are given.
3. Valenstein, *Handbook of Chinese Ceramics*, p. 110, n. 105. Valenstein discusses the 1087 tomb at Susong xian on pp. 110-11 and in Appendix I, p. 299.

44.
LARGE QINGBAI BOTTLE OF MEIPING SHAPE
Northern Song Dynasty, 11th century
Jingdezhen kilns, Jiangxi province
H. 29.2 cm (11 1/2 in.)

From a narrow, circular foot rim, the walls of this ovoid bottle curve gently upward and outward toward a broad, rounded shoulder. A slightly raised collar encircles the shoulder, from which rises a short straight neck, surmounted by a flanged lip rim. Decoration is minimal, consisting only of the raised collar at the shoulder and five pairs of incised vertical lines extending from the collar to the foot. The bottle is covered with a translucent pale blue glaze applied in two layers, the first stopping just above the foot, and the second, midway down the body. The foot rim and base are unglazed, revealing the white porcelain body burned slightly pinkish in the firing.

The restrained decoration testifies to the aesthetic of understated elegance so pervasive during the Northern Song. The slightly raised collar encircling the shoulder and the finely incised vertical lines from collar to foot subtly emphasize the special characteristics of this quintessentially Song shape. Often called *meiping*, or "plum vases," bottles of this shape were not used as vases during the Song, Jin and Yuan periods, but rather functioned as storage containers for wine or other liquids.[1] Ultimately deriving from an early Song silver shape, the *meiping* was soon imitated in ceramic wares of various types.

While there is little documentary evidence recording contact between different kiln sites, strong visual evidence of the interrelationship between kilns manufacturing different types of wares abounds, particularly in Song ceramics. The Barron *qingbai* bottle has an earlier counterpart in a tenth-century Yue-ware bottle, formerly in the collection of Dr. Ralph Marcove.[2] Although somewhat smaller, the Yue bottle is almost identical in shape and decoration.[3] Other similar *qingbai* bottles exist in Western collections, including those formerly in the collection of King Gustav VI Adolph of Sweden,[4] and the Victoria and Albert Museum.[5]

1. See Mowry, *Hare's Fur*, p. 253, for a discussion of the term, the shape and its history.
2. Now in the collection of the Sackler Museum, Harvard University.
3. See Yutake Mino and James Robinson, *Chinese Relics from the Collection of Dr. Ralph Marcove* (Indianapolis, 1981), p. 33, no 39, and James Robinson, "The Marcove Collection," *Orientations* 12 (October 1981): 37 n. 10, fig. 6.
4. Illustrated in Kōyama and Pope, eds., *Oriental Ceramics, The World's Great Collections*, vol. 9, *Museum of Far Eastern Antiquities, Stockholm*, no. 50, and Hasebe, *Sekai Tōji Zenshū*, p. 171, pl. 164.
5. See Kōyama and Pope, eds., *Oriental Ceramics, The World's Great Collections*, vol. 6, *The Victoria and Albert Museum*, pl. 87.

45.

DEEP QINGBAI NOTCHED BOWL WITH INCISED FLORAL DECORATION

Northern Song Dynasty, early 12th century
Jingdezhen kilns, Jiangxi province
D. 18.4 cm (7 1/4 in.)

This deep bowl's flaring sides rise from a high circular foot that culminate in a foliate lip divided into six lobes by shallow notches in the rim. The interior is carved with a design of scrolling stems bearing small rounded leaves and three small blossoms, two of triangular shape and one depicted in profile on a stippled background. The bowl is thinly potted and covered with a translucent glaze of pale blue color. On the base there is a circular area of brownish discoloration resulting from the kiln support on which the bowl was fired.

Three *qingbai* bowls with similar decoration, including one of identical shape, were among eighteen *qingbai* wares recovered from a tomb datable to 1108.[1] Discovered in 1987 in Jinxi County, Jiangxi Province, these porcelains are thought to come from the Nanfeng kilns, one of the most important Song-dynasty complexes in Jingdezhen.[2] Bowls featuring similar carved decoration can be found in several collections, including one from the Qing court collection in the Palace Museum, Beijing,[3] the Carl Kempe Collection and the Museum of Fine Arts, Boston.[4]

1. See Chen Dingrong, "Jiangxi Jinxi Song Sun Dalang mu," *Wenwu* 9 (1990): 15, fig. 2:3; and p. 16, no. 5. The bowls are currently in the Jiangxi Provincial Museum.
2. Ibid., 18.
3. Palace Museum, Beijing, *Complete Collection of Treasures*, vol 33, no. 81.
4. Both are illustrated in Wirgin, *Sung Ceramic Designs*, pl. 13a, 13b. The evolution and variations in the design, which Wirgin dates to the Northern Song period, are discussed on p. 51, with further illustrations in fig. 3.

SIDE VIEW

46.
NOTCHED QINGBAI BOWL WITH CARVED PEONY DESIGN
Northern Song Dynasty
Jingdezhen kilns, Jiangxi Province
D. 19 cm (7 1/2 in.)

Published/Exhibited: Wood, *Art of China and Japan*, p. 2.

Provenance: H.M. Knight

Of shallow form with a six-lobed rim, this thinly potted bowl is decorated in the interior with a carved and combed design of a peony blossom surrounded by foliage. The bowl is covered with a pale translucent glaze except for a circular area of brownish discoloration on the base, left by the kiln support on which it was fired.

The design, incised and with combed details, is among the most beautiful to be found on *qingbai* wares. The pattern covers the whole interior of the bowl and is comprised of two thin, elegant leaf sprays with a big open peony in the middle.[1] Similar bowls can be found in a number of Western collections, including the British Museum and the Museum of Far Eastern Antiquities.[2]

1. See Wirgin, *Sung Ceramic Designs*, pls. 21a, 21b for comparable examples. The design, which Wirgin dates to the Northern Song period, is discussed under Type Cp16, 57.

2. See Kōyama and Pope, eds., *Oriental Ceramics, The World's Great Collections*, vol. 5, *The British Museum. London*, pl. 24 for a very similar bowl, formerly in the Seligman Collection. Another similar bowl, formerly in the collection of Margot Holmes, is illustrated in the same series, vol. 9, *Museum of Far Eastern Antiquities, Stockholm*, pl. 49.

123

47.
SMALL QINGBAI VASE WITH FLARED NECK
Northern Song Dynasty, early 12th century
Jingdezhen kilns, Jiangxi province
H: 18 cm (7 1/8 in.)

A splayed, fluted foot supports the ovoid body of this vase. From the shoulder, which is defined by a slightly raised collar, rises a tall neck with a flaring, everted lip rim. The entire vase, except the foot rim and base, are covered by a translucent pale blue glaze. The unglazed portions reveal a very white porcelain body. The foot was made separately and luted to the body, a join made visible by a slightly raised flat band at the juncture of vase and foot.

The decoration of the vase is comprised of several elements. The tall neck features two strata of incised parallel bands in groups of three and four. A slightly raised collar surrounds the shoulder; beneath this is a wide band of incised abstract floral decoration against a stippled background.

The decorative techniques of stippling and fluting can be seen on a number of Northern Song *qingbai* wares.[1] The distinctive shape and form of this vase is closely related to a group of similar vases recovered from Liao sites in northern China. A taller *qingbai* vase of the same overall shape featuring fluting and stippling and an abstract floral decorative band around the body has been excavated in a Liao tomb in Inner Mongolia. Dating to the end of the Liao period, or the first quarter of the twelfth century, the tomb also contained other *qingba*i wares, Ding wares and Liao metalwork.[2]

Several similar vases exist in collections outside of China. An almost identical vase is now in a Japanese collection,[3] and a closely related vase of similar size, overall shape and construction but with a lobed, rather than decorated body, is in the Percival David Foundation.[4]

1. For a discussion of similar incised designs on a stippled or hatched ground on *qingbai* wares of Northern Song date, see Wirgin, *Sung Ceramic Designs*, Type: C2, p. 51. Wirgin discusses the use of fluting in *qingbai* vases and incense burners or lamps during the Northern Song period under Type: Cp35, p. 66.

2. The tomb find is discussed in Chifengshi bowuguan kaogudui and aluke erqinqi wenwuguan lisuo, "Chifengshi Aluke erqinqi wenduoer Aoruishan Liao mu qingli jianbao," *Wenwu* 3 (1993): 57-67.

3. Illustrated in Osaka Municipal Museum, *Sō Gen no bijutsu* (Osaka, 1978), p. 29, pl. 118.

4. Illustrated in Kōyama and Pope, eds., *Oriental Ceramics, The World' Great Collections*, vol. 7, *Percival David Foundation of Chinese Art*, pl. 9. Formerly in the collection of Mrs. Alfred Clark, this vase is also illustrated in Oriental Ceramic Society, *The Arts of the Sung Dynasty*, pl. 73, no. 201; and in Wirgin, *Sung Ceramic Designs*, pl. 29c.

48.
PAIR OF QINGBAI SAUCERS
Northern Song Dynasty
Jingdezhen kilns, Jiangxi Province
D. 13.6 cm (5 3/8 in.)

These small, shallow dishes stand upon broad, high, circular foot rings. Their gently curving everted sides are divided into eight lobes by means of a notched lip rim, a raised slip line extending from each notch to the broad, flat well and a corresponding incised and indented vertical groove on the exterior. The dishes are covered with a pale blue translucent glaze except for a circular area of grayish-brown discoloration on each base, resulting from the kiln support on which they were fired.

The elegant shape and delicate nature of these dishes epitomize the Song taste for understatement. The use of raised slip lines to articulate their form, a technique seen on other ceramic wares[1] and lacquers,[2] demonstrates the close affinity between various media during the Song period. A number of six- and eight-lobed lacquer dishes of similar shape and comparable lobing techniques now in private collections are attributable to the eleventh century.[3] It is believed that these plain lacquer dishes themselves are derived from silver prototypes.[4] A very similar eight-lobed *qingbai* dish is now in the Museum of Far Eastern Antiquities, Stockholm.[5]

 1. This technique is commonly seen on Ding wares, and is evident in cat. 5 and 7.
 2. An overview of the relationship between Song lacquers and ceramics is presented in Regina Krahl's "Introduction" to Eskenazi Ltd., *Chinese Lacquer from the Jean-Pierre Dubosc Collection and Others* (London, 1992), 9-14.
 3. Eight-lobed, low-footed lacquer dishes can be seen in Ibid. p. 22, no. 3 and p. 56, no. 19, and six-lobed versions are illustrated in Hu Shih-chang et al., *Two Thousand Years of Chinese Lacquer* (Hong Kong, 1993), p. 42, no. 12; Henry Trubner, et al., *Treasures of Asian Art from the Idemitsu Collection* (Seattle, 1981), p. 129, no. 65; and Yu-kuan Lee, *Oriental Lacquer Art* (New York, 1972), p. 112, pl. 48.
 4. Krahl, *op. cit.*, p. 11.
 5. Illustrated in Jan Wirgin, *Sung-Ming, Treasures from the Holger Lauritzen Collection* (Stockholm, 1965), p. 42, no. 29.

49.

SMALL LONGQUAN COVERED JAR WITH INCISED PETAL DESIGN

Northern Song Dynasty, 11th century
Longquan kilns, Zhejiang province
D. 8.2 cm (3 1/4 in.)

The body of this small covered jar is of compressed globular form, the walls arcing outward and upward from a flat, footless base, constricting quickly at the shoulder and terminating in a very short neck. The shoulder and neck are demarcated by a single incised line, and an incised design of vertical overlapping petals, with combed striations defining the interior of each petal, encircles the body of the jar from the shoulder downward. A flat cover decorated with an incised flower-head, with combed details surrounded by a single line, tops the vessel. The jar is covered with a translucent pale green glaze except for the undersurface of the lid, the lip rim and the base where the pale gray porcelaneous stoneware, burned pinkish-orange in places, is exposed.

Small boxes, such as the present example, were produced by various kilns throughout China since at least the Tang Dynasty. Used to hold a variety of cosmetic materials such as lotions, powders, incense, and medicines, each kiln produced a local variant, with differing shapes, sizes, glazes and decoration. This vessel and the covered jar in the next entry, created at the Longquan kilns of Zhejiang province, in the south of China, feature the simple incised designs of overlapping petals typical of Northern Song Longquan ware.

A similarly shaped and decorated jar, formerly in the collection of Mr. and Mrs. Brodie Lodge, is now in the Meiyintang collection.[1] Two other, very similar small boxes with petal decoration and flat covers are in the collection of the Longquan Celadon Museum.[2]

1. See Oriental Ceramic Society, *The Arts of the Sung Dynasty*, pl. 65, no. 189; and Krahl, *Chinese Ceramics from the Meiyintang Collection*, p. 292, no. 547.
2. See Zhejiangsheng wenwuju, *Zhongguo Longquan Qingci* (Hangzhou, 1998), nos. 48-49.

50.
COVERED LONGQUAN JAR WITH INCISED PETAL DESIGN
Northern Song Dynasty, 11th century
Longquan kilns, Zhejiang province
H. 27. 3 cm (10 3/4 in.)

Published: Warren E. Cox, *The Book of Pottery and Porcelain*, vol. 1, rev. ed. (New York, 1970), p. 149, pl. 40.

Provenance: Warren E. Cox

This heavily potted jar rests upon a thick foot. The jar's rounded sides rise upward and slightly outward to the shoulder, where they curve sharply inward, giving way to a tall cylindrical neck that ends in a cupped lip. The broad-rimmed, domed cover is surmounted by a projecting disc and pear-shaped finial. A crackled, glossy, translucent, pale-green glaze covers the exterior of the jar. The light-gray, porcelaenous ware, which has fired pale orange in some places, is visible in the unglazed areas that include the flat undersurface of the lid and the lip rim, foot rim and slightly concave base of the jar.

This covered jar is neatly proportioned and can be divided into three sections. The undecorated upper two-thirds of the jar consists of the lid, with its tall finial, and the upper portion of the jar's body, extending from the lip rim to the shoulder of the vessel. A horizontal groove encircles the body just below the shoulder, demarcating both the lower third of the vessel and the area of decoration. The gentle swelling of the lower portion of the jar is subtly reinforced by the carved overlapping petals with incised striations that comprise the decoration.

An early Longquan covered jar of similar shape, but with more elaborate decoration, was formerly in the collection of Mrs. Alfred Clark,[1] and another, also decorated with an overlapping petal motif, is in the collection of the Longquan Celadon Museum.[2]

1. Illustrated in Oriental Ceramic Society, *The Arts of the Sung Dynasty*, pl. 65, no. 170 and Gompertz, *Chinese Celadon Wares*, 2d. ed., p. 171, no. 73.
2. See Zhejiangsheng wenwuju, *Zhongguo Longquan Qingci*, pl. 44.

51.
PLAIN LONGQUAN DISH WITH FLATTENED RIM
Southern Song Dynasty
Longquan kilns, Zhejiang province
D. 21.3 cm (8 3/8 in.)

Published/Exhibited: Wood, *Art of China and Japan*, p. 20, no. 47.

Provenance: Maria Worthington, Virginia

This large dish stands on a foot of wedge-shaped section, from which rise rounded sides culminating in a broad, everted rim with an up-turned edge. Undecorated, the bowl is covered with a thick blue-green glaze, except for the foot rim, which has burned reddish brown in firing.

Longquan celadons reached their fullest articulation during the Southern Song period. With the decline of the Yue kilns at the end of the Northern Song, the Lonquan kilns rapidly expanded and by the early Southern Song were producing great numbers of celadons for both domestic and foreign markets. The finest Southern Song Longquan wares feature a thick blue-green glaze applied in several layers. The thickness of this glaze would obscure most incised decoration, such as that seen in the previous entries. Consequently, the Longquan potters favored simple, elegant shapes, many of them inspired by archaic bronze and jade forms, as the perfect vehicle for their lustrous glazes.

Excavations at Dayao, a major Longquan kiln site, have revealed a similarly shaped and proportioned dish, datable to the Southern Song period.[1] Other similar examples presently outside of China include a bowl in the Hirota Collection in the Tokyo National Museum,[2] one in the Percival David Foundation,[3] and another, formerly in the collection of J. C. Thomson.[4]

1. Zhejiangsheng Qinggongyeting, ed. *Longquan Qingci Yanjiu* (Beijing, 1989), p. 56, fig. 10:1 illustrates this dish by line drawing, with a photograph appearing in pl. 22:2.
2. Illustrated in Tokyo National Museum, *Illustrated Catalogue of the Tokyo National Museum, Chinese Ceramics*, vol. 1, p. 130, no. 522.
3. Seen in Percival David Foundation, *Illustrated Catalogue of Celadon Wares in the Percival David Foundation of Chinese Art*, rev. ed. (London, 1997), no. 213.
4. Illustrated in Sotheby's, London, *Fine Chinese Ceramics and Works of Art* (June 15, 1982), p. 50, no. 69.

133

52.

FLAT-RIMMED LONGQUAN BRUSH-WASHER

Southern Song Dynasty
Longquan kilns, Zhejiang province
D. 14.6 cm (5 3/4 in.)

Exhibited: Oriental Ceramic Society, *The Arts of the Sung Dynasty*, pl. 66, no. 181.
Published: Gompertz, *Celadon Wares*, no. 14B.

Provenance: Mr. and Mrs. F. Brodie Lodge

From a delicately potted foot, the walls of this brush-washer extend outward, almost parallel to the ground, before rising at a ninety-degree angle upward, where they turn sharply again to form a broad, flat, everted lip. The whole is covered with a fine, greenish-blue glaze except for the foot rim that has burned reddish brown in the firing.

This is a rare shape in Longquan celadon, but several similar brush-washers are known. A slightly larger, but otherwise very similar vessel is in the National Palace Museum, Taipei.[1] Two similar brush-washers are in the Percival David Collection, one with its lip bound in metal;[2] the other is covered in a crackled glaze.[3] Another similar brush-washer, with slightly more inclined sides, is in the Cleveland Museum of Art.[4] A larger vessel of this same shape, formerly in the Qing court collection, is now in the Palace Museum, Beijing.[5]

1. Illustrated in National Palace Museum, *Porcelain of the National Palace Museum, Lung-ch'üan Ware of the Sung Dynasty* (Hong Kong, 1962), plates 18 and 18a, and in National Palace Museum, *Illustrated Catalogue of Sung Dynasty Porcelain in the National Palace Museum, Lung-ch'üan, Ko Ware and Other Wares*, no. 14.

2. This brush-washer has been illustrated a number of times, see Gompertz, *Chinese Celadon Wares*, p. 138, no. 69; Tregear, *Song Ceramics*, p. 173, no. 233; and most recently, Percival David Foundation, *Illustrated Catalogue of Celadon Wares* p. 39, no. 247.

3. See Kōyama and Pope, eds., *Oriental Ceramics, The World's Great Collections*, vol. 7, *Percival David Foundation of Chinese Art*, monochrome pl. 36; and Tokyo National Museum, *A Hundred Masterpieces of Chinese Ceramics from the Percival David Collection* (Tokyo, 1980), b/w pl. 28.

4. Illustrated in Jennifer Neils, ed., *The World of Ceramics, Masterpieces from the Cleveland Museum of Art* (Cleveland, 1982), p. 105, no. 109.

5. Illustrated in Palace Museum, Beijing, *The Complete Treasures*, vol. 33, p. 145, no. 130.

53.
SHALLOW LONGQUAN SAUCER DISH WITH CARVED PETALS
Southern Song Dynasty
Longquan kilns, Zhejiang province
D. 14 cm (5 1/2 in.)

Resting on a neatly potted, slightly tapered foot, the rounded sides of this saucer dish curve outward, forming a broad-based dish of shallow proportion. A band of deftly carved, overlapping petals decorate the exterior of the vessel. A thick, bluish green glaze covers the dish, except for the foot rim, which has burned reddish-brown in the firing.

Several nearly identical Longquan shallow dishes have been unearthed from Southern Song contexts. Included in a cache of celadon, black-glazed, and other ceramic wares discovered in 1963 in a Song-dynasty well near Majiaqiao, Shaoxing in Zhejiang province, is a remarkably similar vessel.[1] Another nearly identical vessel has been more recently unearthed in Zhejiang.[2] A similarly conceived shallow bowl with lotus-petal decoration, featuring a slightly everted rim, has been recovered from the major Longquan kiln site of Dayao.[3]

Similar bowls are in the Carl Kempe collection[4] and in a private collection in Taiwan.[5]

1. See Shaoxingxian wenwuguanli yuanhui, "Zhejiang Shaoxing Majiaqiao Song qu fa qu jianbao," *Kaogu* 11, (1964): 558, fig. 11: 5. This line drawing is also illustrated by Wirgin, *Sung Ceramic Designs*, fig. 42c, no. 5.
2. Illustrated in Asahi Shimbun, *Newly Discovered Southern Song Ceramics: A Thirteenth-Century "Time Capsule"* (Tokyo, 1998), no. 46.
3. Zhejiangsheng Qinggongyeting, ed., *Longquan Qingci Yanjiu*, p. 56, fig. 10:2.
4. This bowl is illustrated by Gyllensvärd, *Chinese Ceramics in the Carl Kempe Collection*, p. 58, no. 128.
5. Illustrated in Chung-hua min kuo wen wu i shu p'in shou ts'ang chia hsieh hui, *Ch'ing Tz'u chih mei* (Taipei, 1991), no. 77.

54.

DEEP LONGQUAN LOTUS BOWL WITH INCISED PETAL DECORATION

Southern Song Dynasty
Longquan kilns, Zhejiang province
D. 14 cm (5 1/2 in.)

Exhibited: Wood, *Art of China and Japan*, no. 50.

Provenance: Frank Caro

Thinly potted and of deep shape, this bowl has rounded sides rising from a small foot and is decorated on the exterior with carved narrow vertical petals. It is covered with a widely crackled, bluish-green glaze except for the foot rim, which has burned a reddish-brown color in the firing.

Longquan bowls of similar size, shape and decoration have been found in a number of Southern Song kiln site excavations and datable tombs. Excavations at the major Longquan kiln sites of Dayao[1] and the nearby site of Jincun have both uncovered similarly shaped and decorated bowls, with that at Jincun being more heavily constructed.[2] A cache of objects from a tomb in Zhejiang, datable to 1274, also included a very similar bowl.[3] Closely related bowls in Western collections may be found in the Percival David Foundation.[4]

 1. Illustrated by a line drawing in Zhejiangsheng Qinggongyeting, *Longquan Qingci Yanjiu*, p. 53, fig. 8:1.
 2. Ibid., p. 85, fig. 13:1.
 3. This bowl is illustrated in a line drawing in Quzhoushi Wenguanhui, "Zhejiang Quzhoushi nan Song mu chutu qiwu," *Kaogu* 11 (1983): 1004, fig. 1:3.
 4. Percival David Foundation, *Illustrated Catalogue of Celadon Wares*, p. 27, no. A211 and p. 43, no. 263.

55.
FLOWER-SHAPED LONGQUAN BOWL
Southern Song Dynasty
Dayao kilns, Longquan region, Zhejiang province
D. 12.3 cm (4 3/4 in.)

Exhibited: Wood, *Art of China and Japan*, no. 25.
Published: Warren E. Cox, *The Book of Pottery and Porcelain*, rev. ed., vol. I, pl. 47.

Provenance: Warren E. Cox
 Richard Bryant Hobart

Rising from a short, straight foot, this bowl's steeply rounded sides terminate in a scalloped rim. This undulating rim corresponds to the incised design on the interior of the bowl, which is comprised of six broad overlapping petals representing a mallow blossom. A translucent grayish-green glaze covers the bowl, except for the foot rim, which is partially glazed, and the unglazed base, which reveals the dense, light gray porcelaneous body.

During the Song period, the mallow-flower was a commonly employed decorative motif, and bowls and dishes with this distinctive overlapping of petals can be seen in a variety of media. A number of surviving lacquer dishes feature this particular shape, although most often in the shallower form of a dish. Two such lacquer dishes, one with six lobes and the other with seven, are currently in a Hong Kong collection,[1] and another, identical to the six-lobed Hong Kong dish, is in the Los Angeles Country Museum of Art.[2]

A number of very similar bowls have been excavated from the Jincun kilns near Dayao in strata datable to the mid- to late Southern Song period.[3]

 1. See Hu, *Two Thousand Years of Chinese Lacquer*, nos. 17-18.
 2. See George Kuwayama, *Far Eastern Lacquer* (Los Angeles, 1982), no. 5.
 3. These bowls are illustrated in Zhejiangsheng Qinggongyeting, ed., *Longquan Qingci Yanjiu*, p. 77, fig. 8:3 (line drawing) and pl. 30:6.

56.
LONGQUAN CONICAL BOWL
Southern Song Dynasty
Longquan kilns, Zhejiang province
D. 14.6 cm (5 3/4 in.)

Provenance: Herschel V. Johnson, U.K.
Col. and Mrs. R.J.H. Carson, U.K.

This conical bowl rests upon a small delicately potted foot, from which rise widely flaring sides. A small raised, circular boss marks the center of the bowl's interior. Completely without ornament, this bowl is covered with a sage green glaze of bluish tint. The silken-textured glaze covers the entire vessel, excepting the foot rim, and is thicker at the lip rim than elsewhere. The unglazed foot rim reveals the light gray porcelaneous body of the bowl, which has fired, in part, a pale orange color.

Conical bowls, commonly used for the drinking of tea, were produced at Longquan and many other kilns during the Song and later periods. The Longquan potters created bowls such as this for domestic and export markets; similar bowls have been found in both contexts. In 1991 a cache of ceramics dating from the late Southern Song period, discovered in Suining, Sichuan province included three conical Longquan bowls very similar to the present example.[1] Likewise, remains from the well-known shipwreck off the coast of Sinan, dating to the early 1320s, included conical bowls from the Longquan kilns.[2] These bowls, like many of the other Longquan celadons discovered in that wreck, although shipped during the Yuan period, appear to be products of the late Southern Song kilns at Longquan.

Very similar bowls are in the collection of the Zhejiang Provincial Museum,[3] the National Palace Museum, Taipei,[4] private collections in Japan,[5] and the Freer Gallery of Art in Washington, D.C.[6]

1. Illustrated in Asahi Shimbun, *Newly Discovered Southern Song Ceramics*, pp. 40-41, pls. 36, 37, 38. This cache is also discussed in Suining bowuguan, "Sichuan Suining: Jinyucun Nan Song Jiaocang," *Wenwu* 4 (1994): 4-28.
2. Illustrated in Choi Sun'u, ed., *Shin'an Kaitei hikiage bunbutsu* (Tokyo, 1983), p. 26, no. 4.
3. Illustrated in Zhejiangsheng wenwuju, *Zhongguo Longquan Qingci*, no. 69.
4. Illustrated in both the National Palace Museum, *Porcelain of the National Palace Museum, Lung-ch'üan Ware of the Sung Dynasty* (Hong Kong, 1962), p. 82, pls. 32 and 32a; and National Palace Museum, *Illustrated Catalogue of Sung Dynasty Porcelain in the National Palace Museum, Lung-ch'üan Ware, Ko Ware and Other Wares*, pls. 17 and 18.
5. Two are illustrated in Hasebe, *Sekai Tōji Zenshū*, p. 209, pls. 211 and 212.
6. See Kōyama and Pope, eds., *Oriental Ceramics, The World's Great Collections*, vol. 10, *The Freer Gallery of Art, Washington, D.C.*, color pl. 16.

57.
LONGQUAN BRONZE-FORM TRIPOD CENSOR
Southern Song Dynasty
Longquan kilns, Zhejiang province
D. 13.4 cm (5 1/4 in.)

Exhibited: Oriental Ceramic Society, *Celadon Wares*, London, 1947, no. 13, pl. 3; Oriental Ceramic Society, *Ju and Kuan Wares*, London, 1952, no. 94; Wood, *Art of China and Japan*, p. 26, no. 46; Seto, *Ceramics: The Chinese Legacy*, p. 15, no. 10.
Published: Basil Gray, "Chinese Porcelain and Pottery: Some Pieces in the Collection of Mrs. Alfred Clarke [sic]," *The Connoisseur*, April 1953, p. 21:X.

In the form of an archaic bronze *liding*, this censor rests upon three slightly splayed legs that support its shallow, rounded body. The vessel's cylindrical neck ends in a plain wide, everted lip rim. The compressed globular body of the censor is visually minimized by the presence of three slender vertical flanges that extend from a raised band around the shoulder down the tapered legs. Covered overall in a pale green glaze that has a lightly stained wide crackle, the light-gray stoneware of the body is visible only at the tips of the legs, which are unglazed.

The Chinese have burned incense for thousands of years, and the creation of vessels specifically for this purpose dates from as early as the Warring States period.[1] The Shang and Zhou-period bronze *ding*, which served as prototypes for this particular vessel, were not incense burners, but rather containers for the simmering and cooking of grains. During the Northern and Southern Song periods, the interest in antiquity amongst members of the educated elite engendered collections of Shang and Zhou ritual bronzes as well as numerous books illustrating early examples and categorizing vessel types and shapes. As the antiquities themselves could not fulfill a utilitarian function without being damaged, contemporary vessels of bronze and ceramic based on antique models were commissioned. Tripod incense burners were popular products at a number of kilns, including those at Longquan, Jun, and Ru, and can also be seen in Guan wares of the twelfth and thirteenth centuries.

Numerous examples of this type of incense burner exist in public and private collection both in Asia and the West. Among the similar examples are those in the National Palace Museum, Taipei,[2] two, formerly in the Qing court collection and now in the Palace Museum, Beijing,[3] one in the Percival David Foundation, London,[4] and four examples in the Idemitsu Museum.[5]

1. The history of incense burners and their various forms is discussed by Mowry, *Hare's Fur*, pp. 262-265.
2. This incense burner is illustrated in two publications by the National Palace Museum: *Porcelain of the National Palace Museum: Lung-ch'üan Ware of the Sung Dynasty*, pl. 16; and also *Illustrated Catalogue of Sung Dynasty Porcelain in the National Palace Museum: Lung-ch'üan Ware, Ko Ware and Other Wares*, no. 12.
3. See Palace Museum, Beijing, *The Complete Treasures*, vol. 33, nos. 122 and 125.
4. Illustrated in black and white in Kōyama and Pope, eds., *Oriental Ceramics: The World's Great Collections*, vol. 7, *The Percival David Foundation of Chinese Art*, pl. 37, and in color in Percival David Foundation, *Illustrated Catalogue of Celadon Wares*, p. 34, no. 228.
5. These four tripod censors, all dated to the Southern Song Dynasty, are illustrated in Idemitsu Museum, *Ceramics in the Idemitsu Collection* (Tokyo, 1987), nos. 469-472.

58.
LONGQUAN BOWL WITH INCURVED RIM
Southern Song Dynasty
Longquan kilns, Zhejiang province
D. 14.3 cm (5 5/8 in.)

Published/Exhibited: Wood, *Art of China and Japan*, p. 27, no. 51.

The rounded sides of this bowl rise from a small neatly potted foot, flaring outward and then abruptly inward to create a sharply inverted rim. Decorated on the lower exterior with a band of vertical, carved petals, this bowl is covered by an even, bluish-green celadon glaze, except for the foot rim. This unglazed ring reveals the pale porcelaneous body of the ware, which has fired to a pale russet color.

A very similar bowl was discovered in the late Southern Song cache of ceramics at Suining.[1] Excavations in 1960 from the late Southern Song strata at the kiln site of Dayao recovered a similar bowl with slightly more rounded sides, which is now in the collection of the Zhejiang Provincial Museum.[2] Closely related bowls may be found in the National Palace Museum, Taipei,[3] and in the Meiyintang collection.[4]

1. See Asahi Shimbun, *Newly Discovered Southern Song Ceramics*, p. 48, no. 49.
2. This bowl has been published a number of times, originally in *Wenwu* 1 (1963): 27-35; and in the English translation of the article, Victoria and Albert Museum/Oriental Ceramic Society Translations, no. 2: Chu Po-ch'ien, "Report on the Excavation of Lung-ch'üan Celadon Kiln-sites in Chekiang" (London, 1968), fig. 8:7 and pl. IV:7. Most recently this bowl has been illustrated in Zhejiangsheng wenwuju, *Zhongguo Longquan Qingci*, pl. 60.
3. See National Palace Museum, *Porcelain of the National Palace Museum, Lung-ch'üan Ware of the Sung Dynasty*, pls. 25-25a, and also National Palace Museum, *Illustrated Catalogue of Sung Dynasty Porcelain*, no. 20.
4. Illustrated in Krahl, *Chinese Ceramics from the Meiyintang Collection*, p. 292, no. 545.

59.
SMALL LONGQUAN BOWL WITH GROOVED LIP
Late Southern Song Dynasty
Longquan kilns, Zhejiang province
D. 10.4 cm (4 1/8 in.)

Published/Exhibited: Wood, *Art of China and Japan*, no. 48, p. 27.

Provenance: Lord Cunliffe

This bowl, of almost hemispherical form, features rounded sides that rise from a small neatly potted foot and culminate in a slightly everted lip rim. A shallow groove or indentation encircles the bowl just below the lip, giving the vessel a distinctive profile. There is a small circular boss in the center of the interior of the bowl. Sparsely crackled blue-green glaze covers the entire vessel except for the foot rim, where the light gray porcelaneous body has partially burned a pale orange.

A nearly identical bowl was recovered along with a vast quantity of other ceramics from a Chinese cargo ship that sank off the coast of Korea in the early 1320s.[1] As has been previously mentioned, despite the Yuan date of the wreck, many of the Longquan celadons in the shipment appear to have been made during the very last years of Southern Song or at least represent a continuation of Southern Song styles into the middle Yuan. That this bowl is of late Southern Song shape and style is confirmed by the presence of similar bowls recovered from tombs, including one dating to 1274 found in the city of Quzhou, in Zhejiang province.[2] Similar vessels may also be found outside China, including one in the Percival David Foundation[3] and another, formerly in the collection of Georges deBatz.[4]

1. Illustrated in National Museum of Korea, *Special Exhibition of Cultural Relics Found off Sinan Coast* (Seoul, 1977), no. 20. The same bowl is also illustrated in Choi, *Shin'an Kaitei hikiage bunbutsu*, p. 26, pl. 3.
2. This bowl is illustrated in Quzhoushi Wenguanhui, "Zhejiang Quzhoushi nan Song mu chutu qiwu," *Kaogu* 11 (1983), pl. 5:2.
3. Illustrated in Percival David Foundation, *Illustrated Catalogue of Celadon Wares*, p. 40, no. 252 and in Tregear, *Song Ceramics*, p. 180, no. 247.
4. Illustrated in Christie's, New York, *The Georges deBatz Collection of Chinese Ceramics* (November 30, 1983), lot 331.

60.

LONGQUAN DISH WITH MOLDED FISH DECORATION

Late Southern Song - Yuan Dynasty
Longquan kilns, Zhejiang province
D. 13.8 cm (5 3/8 in.)

Provenance: H.M. Knight

This bowl stands on a slightly tapered, square-cut foot, from which rise slightly rounded sides that terminate in a wide, flat everted lip rim. Two plump sprig-molded fish decorate the interior of the bowl. The exterior features a band of vertical carved and incised petals. The entire bowl is covered with a lustrous sea-green glaze except for the foot rim that has burned reddish-brown in the firing.

This type of "fish dish" was a popular product at the Longquan kilns during the late Southern Song, Yuan and early Ming periods. Similar dishes, and sherds thereof, have been retrieved from Southern Song kilns in the Longquan region.[1] Yuan-period sites have included similar dishes in their remains, examples include the early fourteenth-century cistern near Jinning, which contained a similar plate along with *qingbai*, Jun, Cizhou wares and other Longquan celadons.[2] The cargo of the trading vessel that sank off the coast of Sinan, South Korea, in the 1320s also included molded fish dishes of this type.[3]

Dishes of this shape embellished with molded fish are well represented in public and private collections. An example of nearly identical proportion to the Barron dish is found in the National Palace Museum, Taipei.[4] Another similar bowl is in the Percival David Foundation collection,[5] and a larger example in is the Minneapolis Institute of Arts.[6]

1. A number of sherds of this popular type have been published, see: the Fung Ping Shan Museum, *Finds from Ancient Kilns in China* (Hong Kong, 1981), p. 44, no. 98, and Penelope Hughes-Stanton and Rose Kerr, *Kiln Sites of Ancient China* (London, 1982), p. 125, no. 98. Another fragment from a "fish dish" from the Dayao kiln site is illustrated in Zhejiangsheng Qinggongyeting, *Longquan Qingci Yanjiu*, p. 62, fig. 14:5. An entire bowl from Jincun is illustrated in the same publication, pl. 36:3. This same bowl is illustrated in The Victoria and Albert Museum/The Oriental Ceramic Society, Chu Po-ch'ien, *Report on the Excavation of Lung-ch'üan Celadon Kiln-sites in Chekiang*, pl. IV:12.
2. This find is illustrated in *Wenwu* 8 (1979), pl. VI:4.
3. Illustrated in National Museum of Korea, *Special Exhibition of Cultural Relics Found off Sinan Coast* (Seoul, 1977), pl. 28.
4. See National Palace Museum, *Porcelain of the National Palace Museum: Lung-ch'üan Ware of the Sung Dynasty*, plates 23-23a, and also National Palace Museum, *Illustrated Catalogue of Sung Dynasty Porcelain in the National Palace Museum, Lung-ch'üan Ware, Ko Ware and Other Wares*, pl. 26.
5. Percival David Foundation, *Illustrated Catalogue of Celadon Wares*, p. 27, no. 265.
6. See Yutaka Mino and Katherine R. Tsiang, *Ice and Green Clouds: Traditions of Chinese Celadon* (Indianapolis, 1986), pp. 190-191, no. 77.

151

61.

LONGQUAN BOWL WITH CARVED AND INCISED PETAL DECORATION
Yuan Dynasty
Longquan kilns, Zhejiang province
D. 17.5 cm (6 7/8 in.)

Exhibited: Wood, *Art of China and Japan*, no. 63.

Provenance: J.T. Tai

With widely flaring, rounded sides rising from a small foot, this bowl is decorated on the exterior with widely spaced, carved vertical petals, each with an incised outline. The bowl is covered with a sea-green glaze, except for the foot rim, where the exposed grayish-white porcelain body has burned, in part, to an orange color.

Lotus bowls were popular products at the Longquan kilns during the late Song and Yuan periods, as is evidenced by the prevalence of this type of bowl in Yuan burials, storage pits and trading vessels. Among the numerous late Song to Yuan sites that have included similar vessels are the cache at Lueyangxian in Shaanxi,[1] a tomb at Dongxi, Jianyang, in Sichuan province,[2] and a hoard of Longquan celadons discovered in Taojiang county, Hunan.[3] Likewise a number of closely related bowls have been recovered from the 1323 wreck of the sunken trading vessel off the Sinan coast of Korea.[4]

A number of similar bowls are in both Asian and Western collections, including the Lishui city Museum,[5] the Hirota Collection at the Tokyo National Museum,[6] the Meiyintang collection,[7] and the Holger Lauritzen collection.[8]

1. See *Wenwu* 11 (1976), pl. 5:5.
2. See *Wenwu* 2 (1987): 71-73.
3. See *Wenwu* 9 (1987): 21-22, no. 9
4. See National Museum of Korea, *Special Exhibition*, nos. 30-32, and reference pl. 302.
5. Zhejiangsheng wenwuju, ed., *Zhongguo Longquan Qingci*, no. 61.
6. Tokyo National Museum, *Illustrated Catalogues of Tokyo National Museum, Chinese Ceramics*, p. 129, no. 517.
7. Illustrated in Krahl, *Chinese Ceramics from the Meiyintang Collection*, p. 291, no. 543.
8. Illustrated in both Wirgin, *Sung-Ming*, p. 30, no. 5; and Kōyama and Pope, eds., *Oriental Ceramics, The World's Great Collections*, vol. 9, *Museum of Far Eastern Antiquities, Stockholm*, monochrome pl. 145.

62.

PAIR OF LONGQUAN ARROW VASES

Yuan Dynasty

Longquan kilns, Zhejiang province

H. 15.5 cm (6 1/8 in.)

Exhibited: Wood, *Art of China and Japan*, no. 64.

Provenance: Warren E. Cox

Each of the vases in this pair feature a straight foot and pear-shaped body that gives way to a tall, slender neck flaring slightly to the lip rim. Midway up the neck, and mounted at either side, is a pair of loops, or tubular handles. Undecorated except for two incised lines circling the neck between the handles, the vases are covered with a thick, sea-green glaze of silky surface texture. Only the beveled foot rim is unglazed, revealing the light gray body that has burned a reddish-brown color.

Arrow vases, or *touhu*, in Chinese, have a long history, being the primary accessory for a drinking game played by the elite in China since the Spring and Autumn period. Usually made of bronze, these vases functioned as the object into which small arrows were thrown and in which they were kept for storage.[1] The object of the game was to throw all of one's arrows into the mouth of the vessel. For every errant throw, the loser was assessed a penalty drink.[2]

This pair of vases, while in the shape of *touhu*, were intended as small flower vases, possibly for a home altar. The shape, with its undercurrent of antiquity, was an appealing one to scholars during this period of revived interest in the ancients, and the game of *touhu* itself was extremely popular among the Song and Yuan elite. Vessels of this shape, but of varying size, may be found in Longquan and *guan* wares,[3] as well as other media, such as bronze. A bronze vase of similar shape, though somewhat larger size, has been recovered from the sunken Chinese trading vessel off the coast of Korea.[4] The popularity this form with the late Song and Yuan elite is confirmed by the presence of *touhu* in tombs, such as the pair of Longquan arrow vases, the same height but with wider necks, recovered from the tomb of the Yuan calligrapher Xian Yushu (1251-1302).[5]

Similar arrow vases are in public and private collections outside of China, including the former Yamanaka Collection,[6] and that of Inazio Vok.[7] A closely related arrow vase of the same size and shape, but decorated with iron-brown spots (a technique known as "tobi seiji") is currently in the Charles B. Hoyt Collection of the Museum of Fine Arts, Boston.[8]

1. For a discussion of archaic bronze *touhu*, see Robert Mowry, *China's Renaissance in Bronze: The Robert H. Clague Collection of Later Chinese Bronzes, 1100-1900* (Phoenix, 1994), pp. 52-55.
2. For a discussion of the game, its origins, development and culture, see Isabelle Lee, "*Touhu*: Three Millennia of the Chinese Arrow Vase and the Game of Pitch-Pot," *Transactions of the Oriental Ceramic Society*, vol. 56 (1991-92): 13-27.
3. See, for example, the *guan* Arrow vase from the Cleveland Museum of Art, illustrated in Mino, *Ice and Green Clouds*, p. 174, no. 69.
4. This vase was included in the National Museum of Korea, *Special Exhibition*, no. 287.
5. The tomb and its contents are discussed in Zhang Yulan, "Hangzhoushi faxian Yuandai Xian Yushu mu," *Wenwu* 9 (1990): 22-25; the vases are illustrated on p. 24, figs. 11-12.
6. Illustrated in Yamanaka and Co., *Collection of Chinese Art and Other Far Eastern Art* (New York, 1943), no. 748. These vases may, in fact, be the Barron pair.
7. See Museum für Ostasiatische Kunst, *Seladon, Swatow, Blauweiss* (Cologne, 1983), no. 9.
8. Kōyama and Pope, eds., *Oriental Ceramics, The World's Great Collections*, vol. 11, *Museum of Fine Arts, Boston*, monochrome pl. 201.

63.
LONGQUAN BOTTLE OF MEIPING SHAPE
Yuan - early Ming Dynasty, late 14th - early 15th century
Longquan kilns, Zhejiang province
H. 18.4 cm (7 1/4 in.)

Exhibited: Wood, *Art of China and Japan*, no. 69.

Provenance: Frank Caro

This bottle, of classic *meiping* proportion,[1] rests upon a small, sharply everted, thickly potted bevelled foot. The walls ascend from the foot, curving sharply inward, then outward, reaching a broad shoulder, where they again constrict and give rise to a short, flaring neck with an everted lip rim. Three sets of incised double lines, around the collar, shoulder and almost midway between the shoulder and foot, encircle the vase and define the major areas of decoration. A band of quickly sketched vertical petals reaches from the upper edge of the foot to the lower set of incised lines. The main body of the vase, beneath the shoulder and above the petals, features a scrolling design of stems and floral motifs. A scrolling cloud band surrounds the shoulder of the vessel, between the incised shoulder-lines and those that surround the collar of the neck. From this collar arise carved, spikey, upright petals, whose tips form a decorative triangular pattern on the lower portion of the neck.

An undecorated *meiping* in a private Hong Kong collection is of nearly identical shape—including the collared shoulder and bevelled foot—and has been attributed to the Yuan dynasty.[2] A larger Longquan *meiping* of more rounded form, but with very similar carved decoration and construction of the foot, dated to the fifteenth century, is in the Hirota Collection of the Tokyo National Museum.[3]

1. For a discussion of this distinctive shape, see cat. 44.
2. Hong Kong Museum of Art, *Anthology of Chinese Art, Min Chiu Society Silver Jubilee Exhibition* (Hong Kong, 1985), no. 146.
3. Illustrated in Kōyama and Pope, eds., *Oriental Ceramics, The World's Great Collections*, vol. I; *Tokyo National Museum*, monochrome pl. 107.

Selected Bibliography

Addis, John M. *Chinese Ceramics from Datable Tombs, and Some Other Dated Materials*. London, 1987.

Asahi Shimbun. *Newly Discovered Southern Song Ceramics: A Thirteenth-Century "Time Capsule."* Tokyo, 1998.

Ayers, John. *The Seligman Collection of Oriental Art*, vol. 2, *Chinese and Korean Pottery and Porcelain*. London, 1964.

_____. *The Baur Collection*, vol. 1, *Chinese Ceramics (with Korean and Thai Wares)*. Geneva, 1968.

_____. *Chinese Ceramics, The Koger Collection*. London and New York, 1985.

Beijing daxue kaoguxi and Hebei sheng wenwu yanjiusuo. "Hebei sheng Cixian Guantai Cizhou yao yizhi fajue jianbao." *Wenwu* 4 (1990): 1-22.

Beijing daxue kaogu xuexi, et al. *Guantai Cizhou Yaozhi*. Beijing, 1997.

Chang Foundation, *Selected Chinese Ceramics from Han to Qing Dynasties*. Taipei, 1990.

_____. *Ten Dynasties of Chinese Ceramics from the Chang Foundation*. New York, 1993.

Changzhou cheng bowuguan, "Jiangsu Changzhou cheng Hongmeixincun Song mu." *Kaogu* 11 (1997): 44-50.

Chen, Dingrong, "Jiangxi Jinxi Song Sun Dalang mu." *Wenwu* 9 (1990): 14-21.

Chifengshi bowuguan kaogudi and Aluke erqinqi wenwuguan lisuo. "Chifengshi Aluke erqingqi wenduoer Aoruishan Liao mu qingli jianbao." *Wenwu* 3 (1993): 57-67.

Chin, Tsu-ming. "Yü-yao hsien." In Victoria and Albert Museum/Oriental Ceramic Society Translations, no. 6, *Yüeh Ware Kiln Sites in Chekiang*. London, 1976.

Choi, Sun'u, ed. *Shin'an Kaitei hikiage bunbutsu*. Tokyo, 1983.

Christie's, New York. *The Georges deBatz Collection of Chinese Ceramics.* (November 30, 1983).

Christie's. *An Exhibition of Important Chinese Ceramics from the Robert Chang Collection*. London, 1993.

Chu, Po-ch'ien. "Report on the Excavation of Lung-ch'üan Celadon Kiln-sites in Chekiang." In Victoria and Albert Museum/Oriental Ceramic Society Translations, no. 2, London, 1968.

Chūgoku Tōji Zenshū, vol. 4, *Yueyao*. Kyoto, 1981.

Chung-hua min kuo wen wu ishu p'in shou ts'ang chia hsieh hui. *Ch'ing Tz'u chih Mei*. Taipei, 1991.

Cox, Warren. *The Book of Pottery and Porcelain*, rev. ed. vol. 1. New York, 1970.

Eskenazi, Ltd. *Chinese Art from the Reach Family Collection*. London, 1989.

_____. *Chinese Lacquer from the Jean-Pierre Dubose Collection and Others*. London, 1992.

Feng, Xianming, et al, eds. *Zhongguo Taoci 4: Yueyao*. Shanghai, 1983.

Freer Gallery of Art. *Masterpieces of Chinese and Japanese Art: Freer Gallery of Art Handbook*. Washington, D.C., 1976.

Fung Ping Shan Museum. *Finds from Ancient Kilns in China*. Hong Kong, 1981.

Gompertz, G. St. G.M. *Korean Celadon*. London, 1963.

_____. *Chinese Celadon Wares*. 2d ed. London and Boston, 1980.

Gray, Basil. "Chinese Porcelain and Pottery: Some Pieces in the Collection of Mrs. Alfred Clarke." *The Connoisseur*, (April 1953): 18-22.

_____. *Early Chinese Pottery and Porcelain*. London, 1953.

_____. *Sung Porcelain and Stoneware*. London and Boston, 1984.

Gyllensvärd, Bo. *Chinese Ceramics in the Carl Kempe Collection*. Stockholm, 1964.

_____. "T'ang Gold and Silver." *Bulletin of the Museum of Far Eastern Antiquities*, 29 (1957): 1-299.

Hasebe, Gakuji. *Seikai Tōji Zenshū*, vol. 12, *Sō*. Tokyo, 1977.

He, Li. *Chinese Ceramics: The New Standard Guide*. New York, 1996.

Hefeishi wenwuguan lichu. "Hefei Beisong Ma Shaoting fuqi he zangmu." *Wenwu* 3 (1991): 26-38.

Ho, Chuimei, ed. *New Light on Chinese Yue and Longquan Wares: Archaeological Ceramics Found in Eastern and Southern Asia, A.D. 800-1400*. Hong Kong, 1994.

Hochstader, Walter. "Ceramics of the Five Dynasties and Sung Periods." *Hobbies: The Magazine of the Buffalo Museum of Science*, vol. 26, no. 5 (June 1946): 101-46.

Honey, William B. *The Ceramic Art of China and Other Countries of the Far East*. New York, 1954.

Hong Kong Museum of Art. *Anthology of Chinese Art, Min Chiu Society Silver Jubilee Exhibition*. Hong Kong, 1985.

_____. *Chinese Antiquities from the Brian S. McElney Collection*. Hong Kong, 1987.

_____. *Song Ceramics from the Kwan Collection*. Hong Kong, 1994.

Hu, Shih-chang et al. *Two Thousand Years of Chinese Lacquer*. Hong Kong, 1993.

Hu, Yueqian. "Anhui Green-glazed Wares from the Sui to Song Dynasties: Comparisons with Zhejiang Wares." In *New Light on Chinese Yue and Longquan Wares. Archaeological Ceramics Found in Eastern and Southern Asia, A.D. 800-1400*, edited by Chuimei Ho. Hong Kong, 1994.

Hughes-Stanton, Penelope and Rose Kerr. *Kiln Sites of Ancient China*. London, 1982.

Idemitsu Museum of Art. *Ceramics in the Idemitsu Collection*. Tokyo, 1987.

_____. *Unearthed Treasures of China from the Collection of the Arthur M. Sackler Museum of Art and Archaeology, Beijing University*. Tokyo, 1995.

Kaogu. Beijing, 1955-56 and 1972-.

Kōyama, Fujio. *Tōji Taikei.* vol. 38, *Temmoku.* Tokyo, 1974.

Kōyama, Fujio and John Pope, eds. *Oriental Ceramics, The World's Great Collections*, vol. 1-11. Tokyo, 1976-.

Krahl, Regina. *Chinese Ceramics from the Meiyintang Collection.* 2 vols. London, 1994.

Kuo, Jason C., ed. *Born of Earth and Fire: Chinese Ceramics from the Scheinman Collection. Studies in Chinese Art History and Archaeology Series*, vol. 1. College Park, 1992.

Kuwayama, George. *Chinese Ceramics: The Heeramaneck Collection.* Los Angeles, 1974.

_____. *Far Eastern Lacquer.* Los Angeles, 1982.

Lally, J. J. and Co. *Brush and Clay.* New York, 1997.

Lee, Isabelle. "*Touhu*: Three Millennia of the Chinese Arrow Vase and the Game of Pitch-Pot." *Transactions of the Oriental Ceramic Society*, vol. 56 (1991-92): 13-27.

Lee, Yu-kuan. *Oriental Lacquer Art.* New York, 1972.

Leidy, Denise Patry. *Treasures of Asian Art, The Asia Society's Mr. and Mrs. John D. Rockefeller, 3rd Collection.* New York, 1994.

Leth, Andre. *Catalogue of Selected Objects of Chinese Art in the Museum of Decorative Art.* Copenhagen, 1959.

Liaoning Provincial Museum. *Liaoci Xuanji.* Beijing, 1961.

Lindberg, Gustaf. "Hsing-yao and Ting-yao: An Investigation and Description of Some Chinese T'ang and Sung White Porcelain in the Carl Kempe and Gustaf Lindberg Collections," *The Museum of Far Eastern Antiquities Bulletin* 25 (1953): 19-71.

Loo, C.T. *Exhibition of Chinese Arts.* New York, 1941.

Lovell, Hin-cheung. *Illustrated Catalogue of Ting Yao and Related Wares in the Percival David Foundation of Chinese Art.* London, 1964.

Mainichi Shimbusa and Nihon Chugoku bunka. *China's Beauty of 2,000 Years: Exhibition of Ceramics and Rubbings of Inscriptions in the Hsi'an Museum.* Tokyo, 1965.

Mayuyama and Co., Ltd. *Mayuyama: Seventy Years*, vol. 1. Tokyo, 1976.

McElney, Brian S. *Inaugural Exhibition*, vol. 1, *Chinese Ceramics, The Museum of East Asian Art.* Bath, 1993.

Medley, Margaret. *T'ang Pottery and Porcelain.* London and Boston, 1981.

Mino, Yutaka. "Tz'u-chou-Type Ware Decorated with Incised Patterns on a Stamped 'Fish-Roe' Ground." *Archives of Asian Art*, XXXII (1979): 56-70.

_____. *Freedom of Clay and Brush through Seven Centuries in Northern China: Tz'u-chou Type Wares, 960-1600 A.D.* Indianapolis, 1980.

_____. "Recent Finds of Song and Yuan Ceramics." In George Kuwayama, *New Perspectives on the Art and Ceramics of China.* Los Angeles, 1992.

Mino, Yutaka and James Robinson. *Chinese Relics from the Collection of Dr. Ralph Marcove.* Indianapolis, 1981.

_____. *Beauty and Tranquility: The Eli Lily Collection of Chinese Art.* Indianapolis, 1983.

Mino, Yutaka and Katherine R. Tsiang. *Ice and Green Clouds: Traditions of Chinese Celadon.* Indianapolis, 1986.

Mostra d'Arte Cinese. Venice, 1954.

Mowry, Robert D. "The Sophistication of Song Dynasty Ceramics." *Apollo*, vol. 118, n.s. no. 261 (November 1983): 394-402.

_____. "Koryo Celadons." *Orientations*, vol. 17, no. 5 (May 1986): 24-39.

_____. *China's Renaissance in Bronze: The Robert H. Clague Collection of Later Chinese Bronzes, 1100-1900.* Phoenix, 1994.

_____. "Foliate Flower Pot and Basin." In James Cuno et al. *Harvard's Art Museums: 100 Years of Collecting.* Cambridge, MA, 1996, pp. 58-59.

_____. *Hare's Fur, Tortoiseshell, and Partridge Feathers: Chinese Brown-and Black-Glazed Ceramics, 400-1400.* Cambridge, MA, 1996.

Museum für Kunst und Gewerbe. *Tausend Jahre Chinesiche Keramik aus Privatbesitz.* Hamburg, 1974.

_____. *Seladon, Swatow, Blauweiss.* Cologne, 1983.

Museum für Ostasiatische Kunst. *Form und Farbe, Chinesische Bronzen und Frühkeramik, Sammlung H.W. Siegel.* Berlin, 1973.

Museum of Oriental Ceramics. *Masterpieces of Yaozhou Ware.* Osaka, 1997.

National Museum of Korea. *Special Exhibition of Cultural Relics Found Off Sinan Coast.* Seoul, 1977.

National Palace Museum. *Porcelain of the National Palace Museum, Chün Ware of the Sung Dynasty.* Hong Kong, 1961.

_____. *Porcelain of the National Palace Museum, Lung-ch'üan Ware of the Sung Dynasty.* Hong Kong, 1962.

_____. *Illustrated Catalogue of Sung Dynasty Porcelain in the National Palace Museum, Lung-ch'üan Ware, Ko Ware and Other Wares.* Taipei, 1974.

_____. *Illustrated Catalogue of Sung Dynasty Porcelain in the National Palace Museum, Ju Ware, Kuan Ware and Chün Ware.* Taipei, 1978.

Neils, Jennifer, ed. *The World of Ceramics. Masterpieces from the Cleveland Museum of Art.* Cleveland, 1982.

Nezu Museum of Fine Art. *White Porcelain of Dingyao.* Tokyo, 1983.

Oriental Ceramic Society. *Celadon Wares.* London, 1947.

_____. *Ju and Kuan Wares.* London, 1952.

_____. *The Arts of the Sung Dynasty.* London, 1960.

_____. *Iron in the Fire: The Chinese Potters' Exploration of Iron Oxide Glazes.* London, 1988.

Osaka Municipal Museum. *Sō Gen no bijutsu.* Osaka, 1978.

_____. *Catalogue of the Osaka Municipal Museums.* Tokyo, 1980.

Palace Museum, Beijing. *The Complete Treasures of the Palace Museum*, vols. 32-33, *Porcelain of the Song Dynasty.* Hong Kong, 1996.

Palmgren, Nils. *Sung Sherds.* Stockholm, 1963.

Percival David Foundation. *Illustrated Catalogue of Celadon Wares in the Percival David Foundation of Chinese Art*, rev. ed. London, 1997.

Quzhoushi wenguanhui, "Zhejiang Quzhoushi nan Song mu chutu qiwu." *Kaogu* 11 (1983): 1004-12.

Rawson, Jessica. *Chinese Ornament: The Lotus and the Dragon*. London, 1984.

_____. "Song Silver and its Connexions with Ceramics." *Apollo* (London), 120, n.s. no. 269 (July 1984): 18-23.

Robinson, James. "The Marcove Collection." *Orientations* 12 (October, 1981): 36-34?.

Schafer, Edward H. "Blue Green Clouds." *Journal of the American Oriental Society*, vol. 102, no. 1 (1982): 91-92.

_____. *Mirages on the Sea of Time: The Taoist Poetry of Ts'ao T'ang*. Berkely, 1985.

Seattle Art Museum. *Asiatic Art in the Seattle Art Museum*. Seattle, 1973.

Seto, John H. *Ceramics: The Chinese Legacy*. Memphis, Tennessee, 1984.

Shaanxi sheng bowuguan. *Yaoci Tulu*. Beijing, 1956.

Shaanxi sheng kaogu yanjiusuo. *Shaanxi Tongchuan Yaozhouyao*. Beijing, 1965.

Shaanxi sheng kaogu yanjiusuo and Yaozhouyao bowuguan. *Songdai Yaozhou Yaozhi*. Beijing, 1998.

Shaoxingxian wenwu guan liyuanhui. "Zhejiang Shaoxing Majiaqiao Song qu faqu jianbao." *Kaogu* 11 (1964): 558-60.

Sotheby's, London. *Catalogue of Fine Chinese Ceramics and Works of Art*. (May 18, 1971).

Sotheby Parke Bernet, New York. *Important Chinese Ceramics, Jade Carvings and Works of Art*. (October 23, 1976).

Suining bowuguan. "Sichuan Suining: Jinyucun nan Song jiaocang." *Wenwu* 4 (1994): 4-28.

Sullivan, Michael. *Chinese Ceramics, Bronzes and Jades in the Barlow Collection*. London, 1963.

Susong xian wenhua guan. "Susong xian Song mu chutu yi pi wenwu." *Wenwu* 3 (1965): 53-54.

Tianjin Municipal Museum. *Porcelains from the Tianjin Municipal Museum*. Hong Kong, 1993.

Tokyo National Museum. *Illustrated Catalogue of the Tokyo National Museum*. Tokyo, 1965.

_____. *The Hirota Collection, Tokyo National Museum*. Tokyo, 1973.

_____. *A Hundred Masterpieces of Chinese Ceramics from the Percival David Collection*. Tokyo, 1976.

_____. *Illustrated Catalogues of the Tokyo National Museum, Chinese Ceramics*, vol. 1. Tokyo, 1988.

Tregear, Mary. *Catalogue of Greenware in the Ashmolean Museum*. Oxford, 1976.

_____. *Song Ceramics*. New York, 1982.

Trubner, Henry. *The Far Eastern Collection, Royal Ontario Museum*. Toronto, 1968.

_____, et al. *Treasures of Asian Art from the Idemitsu Collection*. Seattle, 1981.

Ts'ai, Mei-fen. "A Discussion of Ting Ware with Unglazed Rims and Related Twelfth-Century Porcelain." In *Arts of the Sung and Yüan*. New York, 1996, 109-34.

Tseng, Hsien-ch'i and Robert Paul Dart. *The Charles B. Hoyt Collection in the Museum of Fine Arts, Boston*. vol. 2, *Chinese Art: Liao, Sung and Yuan Dynasties*. Boston, 1972.

University of Hong Kong Art Gallery. *Ceramic Finds from Henan*. Hong Kong, 1997.

Urban Council of Hong Kong. *Emerald-like Blue Hue Rises: Chinese Ceramics Donated by the K.S. Lo Foundation*. Hong Kong, 1995.

Vainker, Shelagh. *Chinese Pottery and Porcelain from Prehistory to the Present*. New York, 1991.

Valenstein, Suzanne G. *A Handbook of Chinese Ceramics*. rev. ed. New York, 1989.

Vickers, Michael, ed. *Pots and Pans: A Colloquim on Precious Metals and Ceramics in the Muslim, Chinese and Graeco-Roman Worlds*. Oxford, 1986.

Wang, Qingzheng, ed. *Yue Ware: Miseci Porcelain*. Shanghai, 1996.

Wang, Yeyou. "Qiantan Susong xian jinian mu chutu de Beisong qingbai ciqi." *Jingdezhen Taoci* 2 (1984): 60-63.

Ward, Roger and Patricia J. Fidler. *The Nelson-Atkins Museum of Art: A Handbook of the Collection*. New York, 1993.

Watson, William. *Tang and Liao Ceramics*. New York, 1984.

Wenwu. Beijing, 1950-66 and 1972-.

Wirgin, Jan. *Sung-Ming: Treasures from the Holger Lauritzen Collection*. Stockholm, 1954.

_____. *Sung Ceramic Designs*. London, 1979.

Wood, Carolyn H. *Art of China and Japan*. Huntsville, Alabama, 1977.

Wuxi Cheng Bowuguan, "Jiangxi Wucheng Xingzhu Song Mu." *Wenwu* 3 (1990): 19-23.

Yamanaka and Co. *Collection of Chinese Art and Other Far Eastern Art*. New York, 1943.

Yang, Xiaoneng, ed. *The Golden Age of Chinese Archaeology: Celebrated Discoveries from the People's Republic of China*. Washington, D.C., 1999.

Zhang, Yulan, "Hangzhoushi faxian Yuandai Xian Yushu mu." *Wenwu* 9 (1990): 22-25.

Zhao, Qingyun. *Henan Taoci Shi*. Beijing, 1993.

Zhejiangsheng Qinggongyeting, ed. *Longquan Qingci Yanjiu*. Beijing, 1989.

Zhejiangsheng wenwuju. *Zhongguo Longquan Qingci*. Hangzhou, 1998.

Zhou, Zhenxi, "My Work on Yaozhou Kiln Sites." *Transactions of the Oriental Ceramic Society*, vol. 61 (1996-97): 1-7.